"*Vanishing Streets* is a vivid, sensual, and multi-directional take from a masterful writer who knows his craft, knows himself, and knows London. London is my favorite city on earth, and this book is a treasure house for all who adore this capital city."

> —Jay Parini, author of *The Last Station* and
> *Empire of Self: A Life of Gore Vidal*

"J. M. Tyree writes gorgeously, hauntingly of London. He enchants with ghostly byways, mythical wellsprings of memory, and astonishing secret civic trapdoors that lead to taproots of personal and cinematic identity. This is a dreamy subterranean work where one can equally find echoes of other cities—yours and mine—buried alive, subconsciously in sync with the great vanishing streets of a great city."

> —Guy Maddin, director of *My Winnipeg*

"*Vanishing Streets* encompasses so many different forms: it's a travelogue through an endlessly fascinating city, a deeply affecting memoir, and an elegy for London. J. M. Tyree's voice is myriad as well: wise and ironic and funny and frank and searing and honest. Readers will want to remain in Tyree's London long after they finish this book, drunk with wandering and wondering."

> —Jesmyn Ward, author of *Salvage the Bones* and
> *Men We Reaped*

"*Vanishing Streets* re-maps London. As both intimate guide and wide-eyed outsider, J. M. Tyree dwells in the places and histories lesser writers would ignore. Through his wry photos, searching intelligence, and witty, incisive prose, he imbues every street and every sentence with wonder and mystery. London is the most-visited city in the world. Open this book and see it anew."

—Will Boast, author of *Epilogue: A Memoir*

"J. M. Tyree's *Vanishing Streets* is a journey through the streets of London—and also through loss and failure, and, most of all, through the writer's 20-year love affair with his wife. In turns delightful and heartbreaking, Tyree's is the best kind of travel writing; it is an exploration of how one place can vividly reveal us to ourselves."

— Miranda Kennedy, author of
Sideways on a Scooter: Life and Love in India

"*Vanishing Streets* is difficult to classify—parts travelogue, guidebook, and criticism, maybe even a bit of memoir—but this strange and wonderful book is easy to like. J. M. Tyree writes with wit and insight about everything from Free Cinema to his marriage to gentrification. These idiosyncratic tours of London create a mosaic portrait of his city that feels like a gift to its reader."

—Justin St. Germain, author of *Son of a Gun*

STREETS

JOURNEYS IN LONDON

J. M. TYREE

REDWOOD PRESS STANFORD, CALIFORNIA

Stanford University Press
Stanford, California

Printed in the United States of America on acid-free, archival-quality paper

Library of Congress Cataloging-in-Publication Data

Names: Tyree, J. M. (Joshua M.), author.
Title: Vanishing streets : journeys in London / J. M. Tyree.
Description: Stanford, California : Redwood Press, 2016.
Identifiers: LCCN 2016019731| ISBN 9781503600034 (cloth : alk. paper) |
 ISBN 9781503600942 (electronic)
Subjects: LCSH: Tyree, J. M. (Joshua M.)—Travel—England—London. |
London
 (England)—Description and travel. | London (England)—In motion
pictures.
Classification: LCC DA684.25 .T97 2016 | DDC 942.1—dc23
LC record available at https://lccn.loc.gov/2016019731

Designed by Rob Ehle
Typeset at Stanford University Press in 10.75/16 ADScala

CONTENTS

LONDON IS

MY MISTRESS

FREEDOM
OF THE
CITY

NOBODY UNDERSTOOD why I wanted to spend a month in North London during the winter. My wife had landed a precious academic sabbatical. Emily had zero interest in walking freezing rainy February streets haunted by her childhood memories of Islington in the age of Margaret Thatcher. We had argued—nothing serious, I hoped—about what to do with this lucky chance of time off. She was ready to start a family, but I hadn't had a salary in three years. I was forty-one and prone to depression in the years after the Crash. Pushing a stroller as my primary occupation wouldn't help—or maybe it was just what I needed. We agreed to go our separate ways for some thinking time and meet up in a month to talk things over.

Emily's Facebook feed started bursting with colorfully filtered snapshots of orange trees in Seville, carnival singers marching through sun-splashed Cádiz. I looked outside and saw a spider's web of electrical wires looming in the cold mist above the gray brick rows of terraced houses near Finsbury Park, N4. Late afternoon gloom gathered in the secluded nooks of the park and the abandoned rail stations whose vanished tracks now formed

a footpath to Highgate. I envisioned the diesel fumes of stalled-out rush-hour journeys choking the intersection between the Underground station and the Finsbury Park Mosque. The sodden gutters near Seven Sisters Road and Blackstock Road linked betting shops and Ethiopian restaurants, SIM-card kiosk guys and South Asian clothing merchants, the fragrant bagel bakery and the old pub signage for Courage beers and Meux's Original London Stout. Here was the housing estate off Fonthill Road that replaced a demolished warren where a century ago the local gangs were said to speak their own coded language. In the plaza in front of the station loomed the bowling alley that used to be the Rink cinema. In its heyday the Rink had a seating capacity of over a thousand and plenty of room for prostitutes to operate in the warm darkness during the Great War.

I would have liked to take Emily to visit the animal charity bookshops that faced one another on Blackstock Road—the cat people with their orderly sections and tidy themed displays, and the dog people with their wonderful cramped jumble (or was it the other way around?). These little rooms opened into alternate universes. Behind every shop front in this postcode lay a portal filled with stars. Or so it seemed when the snow drifted like sparks or fireflies in the street-lamps, reflected in dark windows after hours. A bus would gladly take us to Alexandra Palace, where the hill overlooked the entire city from the Olympic Site to Canary Wharf, the City, and the BT Tower. That was my idea of a nice day out, but I would have to go alone.

Emily had already left for Spain, and in February I couldn't convince anyone else to join me. My wife's sister, Joanna, lived in Wandsworth, newly married and planning to relocate to Los Angeles. My best friend in Britain, Ben, lived near Waterloo Station. It was possible to entice South Londoners to cross the river but in the winter there had to be some compelling special event, like a holiday dessert you could soak in alcohol and light on fire. Wiser not to move more than a few paces away from the kettle, December to March.

It had been nearly twenty years since I had experienced winter in England. I grew up in snowy Wisconsin, the land of the ice fishermen, and the London winter was much more miserable. Nothing ever really dried out. You could ward off the chill temporarily with things that warmed from within—tea, booze, smokes—but the damp got in your bones. I read about the homeless who drank wood alcohol concocted in illegal stills around the "beds in sheds" in the vast outskirts. Cheap heroin had been flooding back into London for years. Soup, hot beans, the wrapped

bundle of grease and boiled fish from the chippie. Drinking chocolate, Golden Syrup, Nescafé, Horlicks, Bovril, or in a pinch just a cube of vegetable stock dissolved in boiling water. (I'd seen my wife do this from time to time over the years—Emily emigrated to America at age thirteen, but this act proved she was still British.) The crazy national logic of cellar-cool beer in winter. Pint after pint, measure for measure. Enough drink to make any social outing seem like a conclave of gutter drunks.

After many jetlagged sleepless mornings and a long ride on a night bus with a broken heater, I got the flu and my brain started cooking itself. Semidelirious, it suddenly occurred to me that I had been having an affair with London, right under my wife's nose, in her parents' flat, for almost twenty years. During the time I had been visiting London—since 1996 when I was a student on scholarship at Cambridge—I had become addicted to wandering around the vaguely spleen-shaped area between the A1, the North Circular Road, and the A10. Or maybe I was more like a fake spy, an American tourist working for a fictional international intelligence organization. Collecting useless files and furtive accidental snapshots, street by street. My assignations with invisible lovers or nonexistent espionage contacts took place near statues of cats in Archway, along the canals of the New River, around the Nazi bomb sites of Stoke Newington.

What is it with you and London? Emily wanted to know. On Skype she was relaxing outside on a sunny patio in Seville, talking about an endless succession of warm days and the grammatical complexities of the subjunc-

tive. About palaces filled with fruit trees, tiles, flowers, fountains, and peacocks. Her skin had browned beautifully in the sun, and her green eyes looked greener in the sharp southern light.

London was played out, Emily had been arguing for years. The city had transformed itself into a distasteful pseudo–New York, a playground for the world's wealthy with their resplendent investment properties and river views. Global real estate developers raised Mordor-Lite towers along the riverside beyond Greenwich, while Australian chain malls dominated Stratford and White City. Rents doubled to clear out the poor. Teachers, artists, and writers fled the city in droves.

What is left? Emily often asked me. Americans eating lunch in Starbucks? Besides, she said, on a purely visual level Seville makes London look like a junkie waking up in a trashed squat with puke in his hair.

I could never sufficiently explain my attraction for London, because it was deeply irrational. I knew that the city remained as fascinating and fucked up as ever, especially on the peripheries outside of Zones 1 and 2. All I could tell Emily was that I wanted to be in London when I was not there. I enjoyed the feeling of being a blundering outsider in a foreign city where I could still communicate, vaguely, even if I never would be understood. I got magnetized by place names on the bus destination signs, Wood Green and Angel Road. I had to go see what splendors awaited the visitor of Mansion Park and Seven Sisters. I searched for rose gardens, magpies, soothing water, and above all, the real locations connected to the films and books I loved. But over twenty years of travels in the city, I kept returning, unconsciously, to bomb sites, damaged buildings, and canals. Like a character in a horror story, I only saw these repetitions in retrospect when all the photographs I'd taken melded together into the same nightmare.

I had a thing for London cemeteries. I wanted to pause in my wet shoes in a garden graveyard in Stoke Newington to find the monument inscription about the area's civilian dead in the Blitz. On a recent visit I saw a sign that begged whoever stole the flowers from the monument to bring them back. The cemetery gate had been plastered with a pleading notice about a missing cat. But the flier had been defaced so that the cat appeared to be talking back to its owner: "Not coming back but need my meds." I wanted to revisit the spot in Highgate where William Friese-Greene, the pioneer of British

"kinematography," was buried. Greene went bankrupt funding projects with delightfully fanciful names that filled me with hope. The "biophantascope" was a rapid-fire magic lantern, and the "chronophotographic" camera was designed to create the illusion of moving pictures on celluloid. Nearby, the graves of Karl Marx and Herbert Spencer faced off forever, twin specters haunting London and the world. I planned a stroll in Tower Hamlets Cemetery, near the area where W. G. Sebald wrote of walking in *Austerlitz*. I discovered a working beehive in a hidden pocket of graves in this corner of the city—honey in the tombs, pollen of the dead, sweets for ghosts and wanderers.

"It seems as if all romance were over," Virginia Woolf wrote of the early 1930s docklands in *The London Scene*. "Barges heaped with old buckets, razor blades, fishtails, newspapers, and ashes—whatever we leave on our plates and throw into our dustbins—are discharging their cargoes upon the most desolate land in the world." Woolf described the complicity of the consumer in world trade and its side effects on people and landscapes: "Because one chooses to light a cigarette, all those barrels of Virginian tobacco are swung on shore."

London contained everything that had ever been imagined, from every era and every corner of the globe. London became the ocean and the whale as well as the lion and the unicorn, a set of woefully mixed metaphors whose confusions and wonders always seemed to suit my mood. I wanted to donate my smog-blackened lungs and diseased eyes to the city as medical specimens. I wanted

to arrange new kinds of views. Snapshots created post-
cards from my itineraries. On the backs of the pictures, I
planned to write a series of love letters disguised as trav-
eling notes. Taken together, they would convince Emily
that London was the place for us to live.

MY FAMILY TRACES ITS ROOTS (one of America's
great pastimes) back to Wales and Scotland. My grand-
father spent some of World War II firing howitzers
into the sea at Bude before shipping out for Europe. I
imagined him taking R&R jaunts into London to visit
someone—I doubt this ever happened but his fond-
ness for the city was lifelong. He was an Anglophile of
the Princess Diana, golf, castles, and Harrods variety.
He collected Wedgwood with scenes from Dickens and
postage stamps of the Royal Wedding between Charles
and Diana, that kind of stuff.

I lived in the UK for three years in the late 1990s as
a student at Cambridge. But although I had studied
English Literature I never shared my grandfather's af-
finity for English things because the versions that got
imported to America when I was growing up were snob-
bish. Academic life at Cambridge didn't exactly help with
that impression, and most of my friends were alienated
types who were either gay, from the North, from Europe,
or from state school backgrounds that made them cyni-
cal about the port-passing, gown-wearing, don't-walk-
on-the-grass, sneering-supervisor style that was still in
fashion in certain quarters of certain subjects at certain
colleges.

Once I had been invited along with dozens of other international students to a meet-and-greet with Prince Charles, at which Lord C—— told me that he knew an American who had recently become a British subject. "Chap by the name of Getty, you might have heard of him?" this Lord joked. I asked him whether the American had done it to dodge his taxes. Another running joke among my friends involved Prince Philip, who apparently had been denied entry to a Cambridge University parking lot by an attendant who noted that Philip didn't have the proper pass. The Prince apparently rebuked him with the eternal words (useful for any occasion), "You bloody silly fool, don't you know who I am?" It was through people like the parking attendant—or the train conductor who once spent twenty minutes on a journey from Glasgow to London explaining Julian Jaynes's *The Origin of Consciousness in the Breakdown of the Bicameral Mind,* or the passport control officer who sang a mocking vulgar song about Cambridge—that I began to warm to England.

At that time they still cultivated the illusion of a Great Britain at Cambridge, and it hadn't been set up for the likes of me. This was the pre–Gordon Ramsay era of British cuisine and you still got served horribly battered food in awkward social spaces filled with intimidating stained glass and portraits of Important Figures You Probably Would Never Become. Attending Trinity College was a little bit like being an exhibit in a living museum. As a student there I sometimes felt like those reenactors at stately homes or castles who dress in period costumes.

When a friend got assigned Ludwig Wittgenstein's old rooms, a philosophy tourist once knocked on the door and asked to take photographs of the study.

When I started visiting London, John Major was prime minister but Tony Blair waited in the wings. The last-ditch Conservative posters depicting him with demon eyes—NEW LABOUR, NEW DANGER—formed a botched prophecy of how Blair would come to be viewed after nearly two decades in power. I quickly realized that Cambridge had warped my vision of what England was all about. I already knew I had been living in a walled garden that was an anomaly detached from the rest of the culture, but the differences still shocked and delighted me when I encountered them close up.

There were women in London, and the women of London . . . well. People in London mixed in from all over the world. London gradually became one of the few places anywhere that I felt comfortable in my own skin. I liked the feeling of being an outsider observing the growth of an infinite complex living organism that always seemed to reflect the current state of things. London remained forever permeable, part of the world in ways that made even New York feel provincial. London was not England, and not definitively European. It would never be America—or whatever world power happened to be in command.

I had never lived so close (an hour from Cambridge to King's Cross) to a great world city. London was my first love. I determined to become another sponge in this ocean, adrift in seas of gray rain and gray streets, low-slung blocks of Victorian flats and horrible 1960s tower

blocks, classic-film locations and hidden street gardens. I knew I'd never see it all if I lived for a hundred years and spent every day doing nothing but walking the streets. The city, unknowable and vast, was only one city, one corner of an island in the Atlantic.

Borges called London a "spider web." In Woolf's *Mrs Dalloway* each life trailed invisible filaments beyond it through the streets. On one visit I went to an exhibition at the National Portrait Gallery on Woolf's relationship with the city. During the Blitz, a placard read, Woolf, "like a tourist in her own city, sometimes made forays after a raid." In *The Voyage Out*, she recommended London for its "vast tumult of life, as various and disorderly as possible."

WHEN I VISITED IN 2011, mass riots exploded all over London, but in my absence in 2012 the Olympics went off without a hitch. When I returned over the next few years, London began to trumpet itself as the "Most Visited City on Earth." A bizarre item in the London *Evening Standard* claimed that international visitors loved the city's welcoming nature. At first I took this as an ironic joke, but as in a very strange dream where everything is upside-down, everyone did seem unnervingly friendly. This change seemed unaccountable—you kept waiting for the other shoe to drop, for the gag to end and the knives to come out. The locals, hopped up on massive doses of expensive coffee, wore shorts in the summer and cracked jokes about global warming. Sometimes people even walked on the *right* in the Tube stations, presum-

ably to accommodate visitors. (Accommodate visitors? What the hell had happened to this country?) Was this more globalization, another ongoing Viking invasion, or was it just the perennial English way of absorbing and blending styles from all over the world, creating catchy pop music out of global ambient moods? Or was it a new form of classic British End Times cheer, "a blitz mentality for Austerity Britain," as an English friend theorized? Why did the proprietor of the local coffee shop ask me for my opinion on whether he ought to stay open late at night or serve food? Enough! If I wanted people to be nice to me I would go to Glasgow.

By the summer of 2014, Britain had "exited depression," according to the economists' moody technical phrasing, yet growth kept backfiring. London, meanwhile, continued to build its new skyline of imposing and wretched skyscrapers. Thatcher's vision of Canary

Wharf as a modern business park got retrofitted to the financial district of the City and to the area around the Olympic Park. An enterprise calling itself the Secret Cinema screened an immersive entertainment version of *Back to the Future* at the Olympic site for fifty pounds a ticket. The animating spirit of the 1980s had returned in force.

The zeitgeist of the Thatcher era had been described by Hackney writer and genius loci Iain Sinclair in his book *Downriver* as a dark time of "riverside opportunities" possessed by "the predatory instincts of men and women in chalked-striped Savile Row suits and yellow hard hats." The political act of building something— anything tall and imposing—recurred under the new Tory government as politicians donned hard hats. Only the suits had changed styles. George Osborne, chancellor under then Prime Minister David Cameron, looked especially goofy in these building-site photo ops, a pale child wizard of digital capital. (Or perhaps a bloodless revenant seeking property expansion in London—Harry Potter crossed with Count Dracula.) Theresa May, home secretary and Cameron's successor at 10 Downing Street, published plans to legalize universal digital surveillance as the pinnacle of her policy objectives; perhaps the Eye of Sauron might be installed on the top floor of the Shard skyscraper?

But during those years it was another player in the Tory Game of Thrones, Boris Johnson, who had become ubiquitous in London, even after his stint as mayor ended. For a long time, Boris was everywhere, not only his foppish

shock of blonde hair and Oxbridge babble but his name. Boris Bikes: the city cycle share. Boris Island: a fictional global airport in the Thames estuary. Boris as a first-name-basis leader, like a king or a pope. His unfinest hour? When he appointed himself the "acceptable" face of the deceptive campaign to leave the EU.

During the London riots a young black protester in a school uniform had confronted Johnson in front of a television camera and encapsulated the entire era: "Now they're looting. There's a reason for everything, Boris. Think about the amount of times you are cutting and cutting and cutting!" During the Cameron-Boris years, council housing rights were threatened and low-income student grants canceled, while a cable car system had been installed and plans were drawn up for a garden bridge over the Thames. The protester pointed out that he had friends who could no longer afford to think about college. I half expected Boris to turn to his young constituent and quote from Thomas Pynchon's novel *Gravity's Rainbow*: "You didn't really believe you'd be saved. Come, we all know who we are by now. No one was ever going to take the trouble to save you, old fellow."

DURING A SUMMERTIME VISIT I began to explore the locations depicted in the Free Cinema films of the 1950s. This project became slightly obsessive. Free Cinema was Lindsay Anderson's marketing label for the short films he was making with his colleagues in London. His Free Cinema Programmes advertised the early works of the British New Wave directors Karel Reisz, who went on to

direct *Saturday Night and Sunday Morning* and *The French Lieutenant's Woman*, and Tony Richardson, who later made *Look Back in Anger* and *Tom Jones*. And of course Anderson helped promote himself—after Free Cinema he directed *This Sporting Life* and *if.* . . .

Free Cinema, by Anderson's account, was born of "the miserable difficulty of getting our work shown. . . . I came up with the idea (at least I think it was me) that we should form ourselves into a Movement, should formulate some kind of Manifesto." In reality the first Free Cinema films had been created independently of one another before any concept linked them together. They formed part of a wider landscape of innovative postwar British documentaries, but Free Cinema got the attention of the press. Anderson even persuaded the great Hollywood director John Ford to attend a screening when he visited London to film on location in 1957 for his police drama *Gideon's Day*. Somebody later snuck a Free Cinema picture, *So Alone*—an eight-minute short supposedly released in 1958—into one of Ford's official filmographies, perhaps as a way of claiming the auteur for the movement.

Created on microscopic budgets and with equipment drawn primarily from the Experimental Film Fund of the British Film Institute, Free Cinema invoked the most basic creation myths of neorealism: you took a camera out into the street and made a little film with whatever was on hand. You filmed it like you saw it. You recorded whatever happened to happen, like in Antonioni's 1948 *N.U.*, a visual essay about the street-sweepers of Rome.

A filmmakers' "Statement" signed by Anderson, Reisz, Richardson, and Italian director Lorenza Mazzetti set out the core beliefs of Free Cinema:

> No film can be too personal.
> The image speaks. Sound amplifies and comments. Size is irrelevant. Perfection is not an aim.
> An attitude means a style. A style means an attitude.

Free Cinema came to be viewed as a collection of shorter films that used handheld cameras and film stock sometimes looted from other productions, short films often shot between other projects, messy films in which the sound sometimes didn't synch perfectly, where the equipment seemed to be begged, borrowed, or stolen, and in which many of the most indelible images of British life seemed to be stolen, too. Regardless of the directing credit on the Free Cinema titles, some of its best footage can be traced back to two figures, sound recordist and editor John Fletcher and cinematographer Walter Lassally. Lassally had worked with Anderson early on, shooting the Academy Award-winning documentary short *Thursday's Children* (1954) about the Margate school for the deaf, and he went on to win his own Academy Award for his black-and-white photography in *Zorba the Greek* (1964). Lassally described in his autobiography, *Itinerant Cameraman*, how he felt that "creative opportunities seem to me to have always been greater on the fringes."

In Anderson's 1957 *Every Day except Christmas* (funded by the Ford Motor Company), the Covent Garden Market was observed over the course of a representative day,

from opening to closing, following the people who move the merch. Reisz produced, Lassally shot, and Fletcher recorded and edited this small masterpiece of minutiae whose leading roles were played by wet London night streets and truck drivers, Kent apples, Norfolk potatoes, and Lincolnshire tulips. The film lingers over the singing warehousemen, the "night-men of the flower stands," and the working-class denizens of down-market London diners, their cheerful but exhausted-looking faces arrayed in John Ford-like tableaux. In his eighties, my wife's father (whose own father worked his way up to manager at Ford Motors in Dagenham) still remembered the inspiring shock of seeing *Every Day except Christmas* at the third series of Free Cinema screenings at the National Film Theatre. The accompanying program, signed by the "Committee for Free Cinema," argued that its goals were "to look at Britain, with honesty and affection," and to "relish its eccentricities; attack its abuses; love its people."

Nice Time (shot and recorded by Fletcher) attempted a parallel project in Piccadilly Circus. In 1957 Claude Goretta and Alain Tanner concocted a symbolic evening amid the seediness and crowded pleasures of the streets and nightlife—American soldiers, trashy movie posters, nude dancing girls—that might have pleased Walter Benjamin during his research on Berlin and Paris. London is free cinema, in every sense. You can watch it but you are also inside the movie. I thought it might be interesting to travel to the spots depicted in these films, not only to retrace the steps of their filmmakers but also to see the

city through double vision, overlaying the present on the past. (Or would it turn out to be the other way round?)

One filmmaker in particular, the Hungarian émigré director Robert Vas, intrigued me most of all. Vas had made only one of the films featured in the Free Cinema programs, *Refuge England* (1959; also shot by Lassally with Louis Wolfers). In another film, *The Vanishing Street* (1962), Vas reflected on the demolition of Hessel Street and environs in the Jewish East End to make way for modern tower block housing projects.

Refuge England was the film I couldn't stop talking about and wanted to screen for everyone I knew. In Vas's movie, a refugee arrives in London from a camp in Hungary with little English and nothing much more on his person than a couple of coins and a resonant address—25 Love Lane. He's been told he can stay there while he establishes himself in his adoptive country. Lassally's involvement added another level of poignancy to the production insofar as the cinematographer had fled Nazi Germany with his family before the war. The

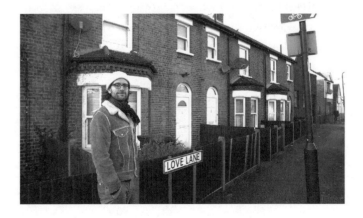

title of the first chapter of *Itinerant Cameraman*—"From DP to DP"—charted his progress from Displaced Person to Director of Photography. A Quaker from Wolverhampton "whom we had never met," Lassally wrote, had guaranteed the refugees a place in England, seeming to mirror the film's storyline as much as Vas's own personal narrative of flight from Hungary to London in the 1950s.

"They told me to choose a place to live," Vas's protagonist says, "and here I am." The pressing problem this refugee faces upon arrival is one endemic to London. He's only been given the address, not the postcode, and he's been given no map and no hint of where in London to find the address. So he embarks on a wild goose chase all over a city that recycles street names in many different neighborhoods. A policeman walking his beat shows him six Love Lanes in the *A to Z Street Atlas*.

My hardcover version of the same atlas, which I had used to chart my own walks through London over the years, listed twelve Love Lanes. Getting from Love Lane in Tottenham to Love Lane in Morden was a seventeen-mile journey that took over six hours to walk. From Love Lane in Pinner to the Love Lane Car Park in Woolwich was an eight-hour hike over nearly twenty-five miles. These two paths met, coincidentally, in the financial district at a crossroads near Leadenhall Market. This spot was not far off from where all treasure was buried—the Bank of England. On Google Street View it was a place where some of the blurry faces waved back at the camera.

Refuge England presents a confused person's first contact with a confusing city, in the process giving the moviegoer an outsider's tour of London. The city is seen through the keyhole of a single place name that replicates itself all over the map, suggesting illicit encounters and sentimental clichés. "For a moment, I felt myself at home," Vas's protagonist says at one point after giving directions to another disoriented walker on the Strand. Vas represents that essential London moment in which someone mistakes a foreigner for a local, and the foreigner somehow manages to point them in the right direction.

BEFORE EMILY'S DEPARTURE FOR SPAIN I had persuaded her to join me at the beginning of my quest to visit every Love Lane in London. My vague plan involved exploring a new part of the city each day. Vas's film acted as my roll of the dice, dictating where I traveled and what neighborhoods I encountered. I hoped to meet the ghosts of Vas, his protagonist, and his film crew, or at least to find out if any of the real Love Lanes had been used as locations in the movie. I wanted to climb into the film and never leave. I wanted to find Vas's character and point him on his way, or hold an umbrella over him as he searched for his symbolic address.

It was on one of these journeys that Emily and I talked about adopting. Maybe we should spend our forties showing another person around the shop. Nothing terrified me more or appealed to me more strongly. I needed a stork to drop the kid at the front door so that I could stop worrying about everything that could go wrong. In

the meantime I wanted to capture Emily smiling in her hometown next to all these silly signs of Love, a conjuring trick to make things right between her and London. But secretly I feared we might be saying goodbye, either to London or to each other. A collage of snapshots would form a wall mosaic that distilled everything into a personal index we might remember as a nice time. These fragments would hold us together no matter what happened. They would form an unbreakable magic spell. Once cast, it would delay Emily's departure—from London, from me, from the world.

So we bundled up against the cold winter night and set off on the Number 4 bus from Finsbury Park Station to EC2 in the City. Love Lane ran between Saint Alban Church Tower, a remnant of the Blitz, and the Shakespeare tribute garden where the "True Originall Copies" of the First Folio stood memorialized in cold stone underneath mountains of glass. We stood very near the ruins of the ancient Roman wall that first divided everything inside the City from everything else in the world. Later, when she had left for Seville and I lingered on in London, I studied a photograph of Emily standing beside the sign for Love Lane, shivering in a soft gray woolen hat and scarf. In her smile I saw that she wasn't just humoring me—she actually wanted to be there, or to be there with me, which amounts to the same thing. Things between us would be okay, at least in this frozen instant.

This location wasn't one depicted in Vas's film, but here we were. Why not take a few snapshots? Behind Emily

stood the tower of the church wrecked in the bombing of 1940. It had been destroyed at least two times before, including in the Great Fire of London in 1666. Fictitious histories piled up around this site of successive ruins in the heart of the financial district. Shakespeare lived nearby. Love Lane got its name from the oldest profession. The infamous "Hanging Judge," George Jeffreys, responsible for notorious seventeenth-century trials and executions, haunted the garden built on the site of St. Mary Aldermanbury, where Jeffreys had been reburied after his death while a prisoner in the Tower of London. Jeffreys had attended my college at Cambridge. We had crossed paths twice now, each time by mistake. I hoped he hadn't yet noticed my steps passing over his head. In one of his decisions Jeffreys had written, "To write is to act."

The Nazis completely wrecked St. Mary Aldermanbury, forever disguising the graves of Jeffreys and of Henry Condell and John Heminges, the actors who edited and published Shakespeare's First Folio. I had accidentally brought Emily to yet another cemetery. And here arose more markers of the Blitz, family memories of her father growing up in Hornchurch, hearing the nightly distant crashing of the bombs of 1940 and collecting crates of shrapnel that had fallen back to earth from the antiaircraft guns near the RAF base. As a young man he had commuted from home to a job in a lawyer's office in the City, changing trains three times on a two-hour journey each way.

I wanted to plant a flag in this ground, to reclaim this jumble. Emily and I were overreaching explorers in the

snow, trying to reenchant a gray emptiness surrounded by the blunt instruments of global finance, those ubiquitous dual-screened monitors behind all that glass. A minor form of heroism involved entering the City of London and returning with any other kind of loot than sterling. St. Mary Aldermanbury had been recreated as a replica in Missouri—we'd traveled to the wrong continent if we wanted to see what it looked like.

Almost certainly our steps were being filmed, in bits and pieces, by CCTV cameras. We had our walk-on roles in the largest movie production of all time. But we also made our own pictures, amateur productions that nobody else would want to see. As for this microcosm of London history we'd blundered into, it stayed with me as an accidental homage to Vas's film.

Emily pointed out her personal sites to me on our bus ride home. *There is the school where my friends who slept over saw the buckets in my room that my parents used to catch the water from our leaking roof. Here's the pool where, after letting kayakers in with canal water on their boats, they overchlorinated, leaving the kids with puffed-up eyes and skin conditions. There is the road where my drunk ex-boyfriend worked with junkies before coming home to piss on the radiator.*

Nothing truly horrible had happened to her. This town just wasn't Emily's idea of fun. Some of these details I already knew, others were new to me.

"You hate it here," I said.

"I like your London," Emily countered. "I have bad memories."

"We can build new ones," I said, hearing American clichés pour out. New memories of what? Winter walks in gardens built on bomb sites that covered up wrecked churches and abandoned cemeteries? I had to do slightly better than that if I ever wanted to convince Emily to return. Even then, I understood that she might never want to go home.

Every visit might be your last. Soak it in.

FERAL
GREEN
PARAKEETS

BEFORE SHE RELOCATED to Los Angeles, my wife's sister, Joanna, liked to visit the Wildlife Photographer of the Year exhibition at the Natural History Museum in South Kensington. Even in the deep middle of winter, the crowds of Zone 1 swelled around the tourist sites. Jostling for position to glimpse images of tiny frogs and undersea wonders, I wondered if conveyor belts might improve the visitor's experience of this cramped would-be Eden. At least that system would give every visitor an equal amount of time in front of the pictures. Conveyor belts would provide the bonus of adding irony to a mechanized appreciation of pristine nature in its wildest form.

Is photography of the photographs allowed? someone asked a museum guard. No metaphotography, please.

Joanna and her husband, Paul, were both photogenic former actors in their midthirties. They had worked in the West End and Paul had appeared on television. Joanna didn't want to do the nudity as an understudy for *Calendar Girls*, and Paul had stopped acting after being a child star in the Dickens franchise productions. They lived in a small flat connected to a shopping mall in Wandsworth

and had met while working at the same catering company. The company treated them well, but they had no clear path to any perch of prosperity in London. They weren't poor but London had succeeded in gradually squeezing them out, in exhausting their idea of the future.

The photography exhibit created a series of rooms in which Joanna could escape from winter—or maybe from London—for an hour or two each year. We entered into boiling deserts and tropical paradises filled with lush vegetation and brightly colored animals from around the globe.

It happened to be an election year in Britain on one of our visits. Over bottles of Crabbie's I asked Joanna if she thought any of the potential outcomes would help her and Paul.

"Cunts in suits," she replied, the British idiom tidily summing up an entire generational sensibility.

At the exhibition, I had become intrigued by an image of wild green parakeets flying at night over the graves of a churchyard in London. I sent the postcard to a friend, writing about how at a certain point you stopped traveling to see the big sights and you looked instead for tiny oddities hidden in the nooks of places, like the cats that sun themselves in Southwark Cathedral and prowl the little park bordering Borough Market. The photo of the parakeets looked haunted, as if these birds were psychopomps, guides to the spirit world for the city's dead, like the owls or crows said to appear to escort the souls of the recently deceased. Only these parakeets materialized as colorful, slightly ridiculous haints—a troupe of jesters sent to joke us away to a silly afterlife.

A month later I sat with my wife in a city park in Seville, where a similar pair of green parakeets appeared above the orange trees of the park with its feral cats, white doves, and little fountains. (And six months later I visited the parakeets of Telegraph Hill in San Francisco on a detour retracing the film locations from *Vertigo*.) These Andalusian birds looked like the cousins of those in the picture in London. I imagined for a moment that maybe these *were* the same birds, on a charming migratory round from Africa to England via Spain. I fancied myself following their route south for the winter. But that was not the case. A little research revealed that the parakeets stayed local to their own area—they acted like quintessential Londoners in that regard. According to the BBC, the varieties of parakeets in London ranged from blue-crowns in Bromley to Alexandrines in Lewisham and monk parakeets whose great stick nests wreak so much havoc with power lines that the authorities steal their eggs in order to keep their numbers down. Monks and ring-necks are often confused because they are both green, leading to slanders against the latter as a nuisance when in fact they are mainly urban broadcasters of intelligent noise.

I could not think of vagrant animals any more lovable or more delightfully deceptive looking. One popular myth, that the parakeets in London had escaped from Shepperton Studios during the shooting of *The African Queen*, concealed the most likely origin of the birds. They were unwanted pets, dumped survivors, rough sleepers—but winged, and soaring above the cemeteries.

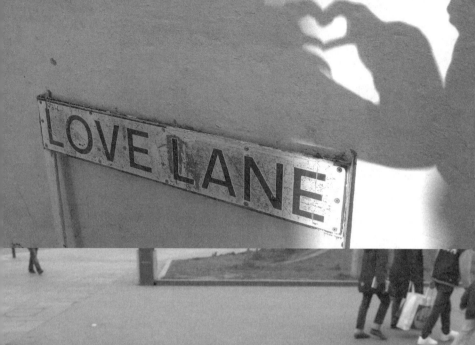

LOVE LANE

Royal Borough of Greenwich SE18

LOVE LANE

25
LOVE LANE

ONE TEST of a foreigner's love of London would be to visit the far northern neighborhoods of the city in February. There were tourists in Tottenham—mad beasts—at this time of year, even in this faraway corner. My brother-in-law, Paul, a Tottenham Hotspur diehard, took me to the 2015 Spurs–Fiorentina Europa League Match at White Hart Lane. The visiting supporters dodged the rain in the Spurs Shop, buying scarves commemorating their away goal in the downpour. They could have waited a week for ultimate victory (3–1 aggregate) in the second leg, back in Italy, in a warm country with a sane national cuisine. The chanting over cold lager in the freezing drizzle of the Tottenham home supporters' pub gardens sometimes sounded crass (I heard a graceless ditty about a doll in the form of an Arsenal supporter—let's just say that something bad happened to the doll). But nobody harassed the Italians in the Spurs Shop, and Paul and I had seats in the corner of joyful old concrete White Hart Lane with the polite families near the disabled access zones. We saw that year's face of English football, Harry Kane, warm up while we wolfed down sausage rolls and

coffee, watching highlight reels on a pitifully small stadium screen. Meanwhile the rain that raineth every day continued to do so.

"NOW LET'S SEE what the weather is doing to us," a BBC presenter had said that week. "Pretty nasty," replied the weather woman—they had a mournful, apologetic air about them as they officiated at the funeral of yet another weekend. Yes, yes, we know, this performance implied, the old terms of our EU membership legally entitled us to live in Málaga, where the winter's highs sometimes reached twenty Celsius, and yet here we all were in London, still, somehow!

One of the live political issues at that time involved the British conviction that along with the weather the country was beleaguered by outside forces. According to estimates from Oxford University's Migration Observatory, the number of migrants in London rose by two hundred thousand from 2011 to 2014, with two-thirds from EU countries. People heard these words—migrants! asylum seekers! benefits claimants!—and reacted badly, like Bram Stoker did when writing *Dracula*, to the Victorian-sounding menace of blood contagion from "the East." *The Romanians Are Coming*, shrieked a television show being advertised during my visit, complete with a clip of a maniacal-looking man withdrawing cash from the barren cupboard of the state. Before the Romanians it was the Poles and after that it would be the Syrian refugees and the phantom menace of the Turks joining the EU that fueled the Brexit referendum campaign—the English xenophobe's *menu du jour*.

The blatant unaffordability of London and the fate of London as a city for anyone on a remotely normal income had become the main obsession of almost everyone I encountered. As a foreign visitor, especially one who jumped from sublet to sublet for years in New York and who has heard these conversations a hundred times before, it was very easy to sympathize. (In the age of Buy to Let, and Buy to Rot—leaving your London investment property empty as a kind of safe—my wife's parents continued inviting actors, writers, and grad students to stay in their spare rooms free of charge.)

Even the thirty-minute train journey from Gatwick cost an insane twenty pounds, making the fee a de facto entrance and exit tax to access the city. Add in the Tube journey to get the train and you already had spent the equivalent of a budget flight to Barcelona just to look at muddy suburban football fields. A Tube ad campaign for virtual business meetings depicted commuting in and out of London as "The Horror," with people in devil masks and high-visibility jackets presiding over traffic nightmares.

On a lark, my friends Ben and Tom went to the sales offices of a fifty-story dildo-shaped luxury tower that was being added to the increasingly grandiose London riverside skyline. A "Pentuplex" crowned the artist's rendering of the building's top four floors, forming the latest feature of the new Billionaire's International Style. A sort of Donald Trump-inspired architectural fashion linked London, New York, Dubai, and other selected cities into a detachable, separate global city-state of extended airport

hotels and shopping centers where the mega-wealthy shuttled between their tacky-glitz high-rises.

The saleswoman at the building's marketing office trumpeted an Executive Lounge high up in the tower—was there ever a sadder concept bar? When asked who would buy these flats, which started above a million pounds, she said, "People such as yourselves?" What they'd be purchasing at that early stage in the development was only an architect's model, a computerized vision of what the view from your flat looked like in theory: the finished product did not yet exist. Could you buy and flip a flat before the completion of construction, my wife asked, and profit from a wholly conceptual transaction on a largely imaginary property? Ben and Tom nodded; surely it was already being done.

Tottenham felt a million miles away from this other London—in truth it might as well have been on another planet. Like everywhere else in London, White Hart Lane was also officially "Under Construction" and the new stadium concept ("Passionate about Tottenham") included the obligatory jargon of urban revitalization and an artist's depiction of admittedly killer-looking flats bordering on the Spurs' new grounds. The last time I had been out here, the area between White Hart Lane and Seven Sisters had been torched by rioters and the high street cordoned off by the police near the looted Carpet Rite. I remembered watching and rewatching a clip of surveillance footage showing a woman grappling with a large carpet as she traveled down the street.

On that visit I had somehow been mistaken for a local

by a student reporter and her companion photographer as I stared up at a gutted building where a red Chinese lamp was dangling in a room exposed to the sky, as if in an image from a bombing.

"What do you think when you see that?" they asked me.

"I don't think anything," I said, at a loss to explain my feelings. I think I sputtered out something about how my wife had been born here and how London meant everything to me. When they realized I was American, they surprised me by getting more interested rather than less so, but then again that was not uncommon, for better and for worse, in the less-traveled precincts.

OVER THE NEXT FEW WEEKS I continued following my personal project. I planned to visit every Love Lane in the *London A to Z*. One of them lurked in Tottenham, a side road near the rail station. My friends and family, politely interested, joined my quests when they had time—a way in to parts of the city we had never visited before, often in the outer areas. Near Love Lane in Woodford Green we found gated mansions, golf courses, a convent. In SE25 we stumbled on a working tram system, painted houses, dank pedestrian rail tunnels, and a Love Lane with a Lidl, Britain's Walmart-esque discounter.

"Why all the Love Lanes?" asked an amused filmmaker I had met at the "Suburbaret" cabaret show in Balham, "an evening of cabaret in celebration of all things suburban!! Burlesque—Comedy—Drag—Music—Spoken Word." The event took place in a peculiar pub that contained a rounded replica of Shakespeare's Globe. I tried

explaining that I was attempting to retrace the film loca-
tions from Robert Vas's *Refuge England*.

"It's the 1950s," I said. "The protagonist is a newly ar-
rived refugee. He's got a piece of paper with an address
on it—25 Love Lane—where he's supposed to go to find
shelter upon landing in England. The problem is there's
no postcode listed, so he has to visit every Love Lane in
the city. I'm trying to retrace his journeys."

The guy looked at me with an appropriate degree of
confused detachment. My friend Ben, who already had
diligently traveled with me to two Love Lanes around
South London that day (someone had stolen the *L*s from
the signs, leaving "ove Lane"), had invited me out to the
Suburbaret. Ben had written several books about film and
television, and he had been the cabaret editor for *Time
Out London*. In his Ph.D. program he studied what he
called "queer fun." The term related to performances
dealing with outsider sexuality and gender identities, but
it seemed applicable to just about everything interesting.
Ben also had become an activist over the years, getting in-
volved in building-preservation battles by virtue of the fact
that cabaret performance spaces tended to be targeted by
developers who wanted to flip old pubs into pricey flats.
He introduced me to the organizer of the Suburbaret,
Gareth, a friendly guy dressed up as a train conductor who
later in the evening read the names of the people killed in
Balham by a Nazi raid. (I discovered a color photo of a bus
lost in a bomb crater near the Balham Tube Station. Ac-
cording to the BBC's "Bomb Sight" web page, "The driver
is believed to have driven into it in the dark.")

After the Suburbaret I decided to push my luck and I took a bus out beyond Morden to find one final Love Lane, in Cheam. The roads out there widened unnervingly and the town centers stood empty. Love Lane connected the area between Nonsuch Park and Seers Park. Walking along the deserted footpath, I could see stars turning slowly above me. I emerged oddly exhilarated by loneliness and cold to find a road sign on the A217 declaring "C. London 12." The block of houses on the final spur of Love Lane was not in Vas's movie. Vas had sent me on a spacewalk in Sutton, tethered to London by the last empty bus back to Morden Station. But I missed the last train. Rather than taking a cab, I decided to wait for an hour for a night bus, which took some of the Underground workers home after their shift, along with suburban revelers intent on conquering the city center. While I watched the moon ascend slowly over the pub where an older group of drinkers sang "When I'm Sixty-Four," I stamped my feet and muttered to myself, singing Belle and Sebastian's "Waiting for the Moon to Rise" and spouting dumb puns based on *The Lord of the Rings* movies. "Evil is stirring in Morden." My quest seemed somehow slightly less earth shattering than Frodo's, although I had convinced myself that the outer London roadways possessed the power of invisibility and that ringwraiths probably did gallop at night through Nonsuch Park. Reportedly the park was haunted by "shadowy figures and sounds of merriment" from the vanished Nonsuch Palace, one of Henry VIII's hunting lodges. Queer fun.

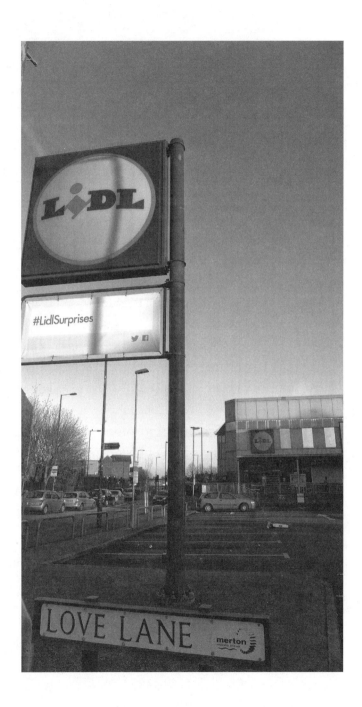

I remained a firm believer in Vas's film, even though he'd sent me on a fool's errand. Vas mostly didn't use the real Love Lanes, and he took various other liberties along the way. Even so, the film revealed London in its vast bafflement, delightful ephemera, tangled overlapping nervous systems, endless suburbs, and wretched weather. *Refuge England* warped the real map of the city, mixing fiction and nonfiction by including places such as Waterloo Bridge, the Strand, and Piccadilly Circus, where the pop art of random nightlife washed tides of neon into the picture. Scowling men in bowler hats; a statue of Johnnie Walker; movie posters; a fortune-telling automaton; shots of passing faces: the film wasn't really about London's Love Lanes after all.

At one point the narrator of *Refuge England* asks whether each person that briefly flashes up on the screen will be the one to offer him a job. He wants to know when or if this city will ever adopt him or accept him, with a "bye-bye and cheerio." He wants to know who or what is to blame for the waves of history pushing lives like his into the breakers. But he also injects notes of humor into the picture by asking, for example, if the dire world situation is the fault of the Planters Peanut advertising mascot, with his pince-nez and cane.

Vas's film, it seems to me, provides a key to unlock unusual views of the city. (It must be said that in all of my travels in search of London's Love Lanes, over dozens of journeys and scores of miles, I only discovered one—the Love Lane in Woodford Green near the edge of Essex—that *might* have appeared as a location in the film. And

that was only for a few moments, mainly as an establishing shot of a suburban street where Vas's character gets offered a cup of tea before being turned away.) *Refuge England* also contains an antidote to the poisonous fear of outsiders and foreigners. Nobody is at home, everyone is lost. In the film Vas's protagonist eventually connects with the generous soul that has offered him a place to stay, despite knowing nothing about his character or the personal history that drove him to this desperate act of migration. Does anyone really think this is something undertaken lightly?

CRYSTAL MEMORY PALACES

I HAVE ALWAYS BELIEVED that North and South London were mirror worlds separated by the river. So that for each and every place, person, and thing above the river, a corresponding item existed below. Someone just like you, a stranger whose life linked to your own in many mysterious ways, lived south of the Thames. Maybe you shared each other's dreams. By this definition London lay flat like a two-dimensional map. Either North London was South London's heaven, or South London was North London's underworld. In any event traveling between the two involved a perilous water crossing, regardless of whether you made the journey on foot, by bicycle, car, bus, or Underground, via bridge, tunnel, or ferry. When you crossed that muddy, sacred body of water, you had to be certain to make an offering to the Three River Sisters. You hung on closely to your wandering soul.

Submitted for your consideration, two magically twinned and interconnected places: Alexandra Palace, far away on a hill overlooking London in Haringey, and Crystal Palace, its opposite and ghostly double. If London were a planet unto itself, you could draw a line of some fifteen

miles between these two palaces and it would serve as a slightly tilted axis that eerily intersected with the strange magnetic forces building the traffic encircling the city. Each of these palaces, at one time, had a television and radio transmission tower, each being the highest spot for miles around. These People's Palaces represented follies in the mold of the Eiffel Tower and the Iberian-American Exposition, the fake Venice in Seville.

You couldn't visit Crystal Palace without a time machine. The place burned down in 1936, leaving its stone sphinxes to molder into the underbrush while a tiny corner of the intricate plate-glass structure endured as an example of what the site might have looked like. So Crystal Palace was a vision of what Alexandra Palace might have become if it had been left to fall to ruins. Or Alexandra Palace, with its rose garden and fountain, duck pond, deer park, ice rink, skate park, and planned television museum, was a vision of what Crystal Palace might look like if it had survived. You couldn't go to Crystal

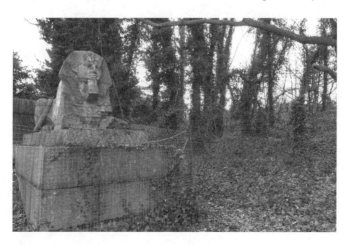

Palace and not think about rebuilding it, or about the vagaries and historical accidents that spared some places and destroyed others. Sphinxes patrolled both palaces but their riddles got confused.

I walked there with my wife's sister after we had located Love Lane, SE25, a footpath that follows an overgrown edge of the South Norwood Country Park. After we traveled through a dark underpass tunnel at the end of the path, I felt a little bit worried that I had wasted her day off. I had told her about my plan to visit all the Love Lanes in the street atlas, searching for the real-life locations from Robert Vas's film *Refuge England*.

"Is this spot in the movie?" Joanna had asked before we set out.

"I doubt it," I said, and I was right. "We could walk to Crystal Palace afterwards."

"What's there?"

"I don't know," I said. "I've always wanted to go."

"Why?" she said, but she was smiling already.

"Do you really want to leave London for good?" I asked her.

Joanna shrugged, but it wasn't a flippant gesture. She and her husband were busily planning their move to Los Angeles, applying for visas and a Green Card for Paul.

"Why do you like London so much?" she asked.

I was looking for something. I didn't know what it was or where to find it, but I had the feeling that it might be around the next corner, or just past the end of the last stop on the bus route. I almost never felt this way back in the States.

"You know," I said, "I fell in love with your sister and London around the same time. Maybe I got them mixed up."

"She doesn't like it here."

"Not much."

"I think you're crazy."

My wife had left for Spain but maybe I would see Emily in the city anyway, waiting for me on one of these Love Lanes. That would be difficult to explain, but stranger things had happened in London. If the magical theory of the city proved correct, the other Emily, her mirror-image self, lived somewhere down here. I could locate her, start up an affair, and make Emily jealous. She would come back and the two Emilys would merge into one with the help of a local alchemist. We would live together on the river, never allowed to leave the waterside since that would break the spell and divide her back into two.

A simpler explanation for my pathetic fallacy offered itself. I wanted to remain forever in the place where Emily and I first became friends. If I waited long enough she would return. Not a magical city, then, just magical thinking.

When Joanna and I went to Crystal Palace, I kept thinking that a Crystal Palace ought to have a Crystal Skull buried somewhere in a cornerstone, a talismanic protective charm. The February day grew colder and the park unraveled into a set of grand staircases leading nowhere—a bleak overlook with a remarkable sunset. I found the bus station behind the park to be the most fascinating thing about the area. I liked to explore how the infrastructure

of the city fit together. Then we found a little alcove in the broken stone of the back of a sphinx, where people shoved their plastic bottles and candy wrappers.

It had to be done: I tore out a page from my notebook and wrote something cryptic about "the next clue" on a nonexistent treasure hunt. I invented the story as I went. The discoverer of this note, I wrote, must travel to the twinned sphinxes of North London, inside Alexandra Palace, for further guidance. I would have to figure out what to say in the note I would place up there in a secret place near the second sphinx, hoping to please a stranger that might never arrive. That person, if they existed, might wish to retrace my own journey between these two palaces that made up the polar ice caps of the alien planet London in winter.

236

WHEN LEFT to my own devices in London, I liked to ride the buses. Alone, I sometimes rode all afternoon, just thinking and looking out. I liked to write while on the bus. From Finsbury Park I happily traveled to the end of the line in any direction: Archway, Wood Green, Northumberland Park, Hackney Wick, Waterloo Bridge, Trafalgar Square, Battersea Park. A bus pass furnished an inexpensive way to tour the city and included the additional advantage of views of passing street scenes, especially if the bus had an upper deck and you could snag a seat at the front by the large windows. These windows fogged up nicely during rain showers and sometimes smashed into the branches of the older trees that line the roads, if the trees hadn't been trimmed recently, or if the driver was more experienced and hugged the curb very closely as the bus approached its stops.

The overheards on buses were priceless.

"I'm scared of London," one American boy said to his father on the Number 4 as it passed by St. Paul's Cathedral. His baby sister was humming "London Bridge Is

Falling Down." Then she said, "Lots of people are going down to London because today's a sunny day."

Another time an older Cockney couple rode my bus through the City from St. Paul's along Fleet Street, chatting away like they were visiting London as tourists after a long absence in Australia, or outer space. They appeared like characters out of John Krish's 1953 film *The Elephant Will Never Forget*, a sharp-edged documentary about the final days of London's tram system. Krish included working-class songs about the trams, which people rode around the city for fun. If you believed the song lyrics, the trams provided a good spot to meet a girlfriend.

The couple on my bus delighted in calling out the names of things we passed, less like tour guides and more like they were touching a mental rosary.

"Millennium Bridge."

"Fourteen years ago that bridge was swinging so badly you wouldn't dare walk across."

"Devil Tavern. Demolished Seventeen some-odd."

"Look at that shop! Two suits one hundred fifty pound."

"Nobody wears suits anymore."

"Except for weddings."

"And funerals."

"Fancy sitting in front of a Monet at the Courtauld for an hour?"

I guessed that this couple had gotten hold of Freedom Passes, which provided public transport for pensioners at no cost. The unemployed also received a discount on travel. This little act of decency always struck me. It might not be your fault if you lost your job, and you

might need to spend time on the bus looking for work. George Orwell, in *The Lion and the Unicorn*, described Englishness in terms of "solid breakfasts and gloomy Sundays . . . green fields and red pillar boxes." I would add the London buses. There was even a reality TV show about trainee drivers—*The Big Red Bus*—which featured a tearjerker episode with an Eastern European single mom passing the challenging road exam. Your average London bus driver was a combination of X-Wing pilot, threading tricky turns and blasting through narrow lanes between buildings, and Zen master, overcoming the karmic obstacles of road rage, congestion, death-wish pedestrians, and the universal disorder of a city of nearly nine million. Drivers trained in Jedi mind tricks and sometimes, I imagined, they closed their eyes and used the Force.

"They hunt in packs," my wife said about London buses one time as we waited for ours to arrive.

Waiting for a bus near the South Bank, I once heard a father singing to his son one of the old Cockney songs featured in Krish's documentary: "Where did you get that hat, where did you get that tile?"

Krish's film pulsed with anger about the fate of the trams and about what London killed off after the war in the name of progress. The trams composed a specialized way of knowing the city—a linkage of synapses. Krish depicted the authorities taking away one of the more affordable enjoyments of working people. The trams vanished into an obsolete cognitive map whose traces ghosted the city, although they had been brought back

in certain sections of South London. The London bus system represented the closest thing to a contemporary analogue for Krish's trams. The much-lamented classic Routemaster bus had formed another example of pure Englishness. Its system proved difficult for outsiders to understand but it remained completely efficient inside the parameters of its own bizarre logic. You entered and exited the old Routemasters through the back and a conductor came to you to collect your fare and dispense change, like a beer guy at an American baseball game. You could simply hop off the bus from the back whenever you liked, even when the Routemaster was in motion, because it had a doorless entrance with a metal pole to help you balance. This strangely brilliant design involved the premise that the bus could move along before all of the tickets were paid for, which presumably helped speed up travel. It employed two people, the driver and the conductor, rather than one.

The new Routemaster buses, with their glass display-case look—which treats their passengers as specimens in an exhibit (*Individuals Living in Areas Poorly Served by the London Underground System*, c. 21st Century)—generally went despised. What happened to all of the Routemaster conductors, who had to jostle their way through the crowds upbraiding fare-dodgers?

The view from the bus window transformed into the world's longest tracking shot. The journey always reminded me of Lindsay Anderson's film *The White Bus* (1967). Anderson set his film in Manchester, and connected it strongly with the northern sensibility of its liter-

ary source material, a story by Shelagh Delaney. Delaney was the Salford writer whose first play, *A Taste of Honey*, had been adapted for the screen by Tony Richardson in 1961. Delaney wrote the screenplays for both *A Taste of Honey* and *The White Bus*. She later appeared smoking on the cover of The Smiths' album *Louder than Bombs*. Delaney's character in *The White Bus*—simply called "the girl" (played by Patricia Healey)—begins the filmed adaptation as a typist in a dreary London office. She fantasizes about hanging herself before fleeing by train and traveling back to her home in the North. (In the original short story, the girl is only in London on a day-return "football special" train; London's joylessness is attacked with greater specificity in the film.) The girl's trip on a sightseeing bus—painted white with SEE YOUR CITY emblazoned on the open upper deck—takes her along with an international delegation to the heavy industrial sites

and museum oddities of Manchester. In sequences that flip back and forth between black-and-white and color film, the visitors watch iron being forged and tour local taxidermic dioramas of natural history, including stuffed apes and snowy owls. The girl's openness to the peculiarities of her city makes her a symbolic explorer, a metonym for everyone with their eyes open.

I liked to think that the girl's journey through Manchester paralleled the travels of Robert Vas's protagonist through London in *Refuge England*. It would have been nice to introduce these two characters to one another.

THE 236 BUS floated like a bumblebee through a sticky day in July from Finsbury Park to Hackney Wick, shuttling folks through the maze of streets connecting Northeast and East London. I hoped to record a snapshot of yet another London by grabbing a seat on this single-decker bone-rattler and using the window as a kind of antitelevision set. I planned to walk out to the Olympic Park from the end of the bus line.

I got a little excitable when the 236 left Islington and started zigzagging its way through the neighborhoods of Newington Green, Albion Road, and on into Hackney via Dalston. This bus was overcrowded and not air-conditioned. You paid the price for attempting to move east–west in a city that was designed for north–south travel. In some ways the 236 felt like a microcosm of London from the pre-Blair years, a little fishbowl containing those who had been left out of the picture. The route hit on the edges of some of the larger estates that

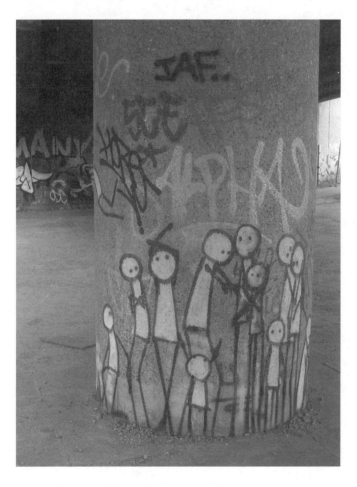

had erupted during the 2011 riots, although of course the entire area was far from immune to the general lunacy of London's massive gentrification project.

I loved every minute of the journey on the 236 because it induced a trancelike meditative state peculiar to London buses. You could not go anywhere fast—at times you couldn't go anywhere at all. In Hackney you encountered the shock and delight of a seemingly endless city regress-

ing into infinity. Inside Hackney, the urban fabric felt coextensive with the galaxy. You read the signs for clues as they flashed by on Broadway Market: FANTASTIC OPPORTUNITIES. MAGIC HAND. CASH X. CAROLINA PIZZA. The palm trees of Hackney Town Hall provided a good joke at the expense of the local populace. The general milling around endemic to London created vast crowds on an aimless weekday, folks out on lunch break or taking a personal day, or whatever. EMPIRE MANSIONS. CASH CONVERTORS. A carefully ripped-up billboard had been repurposed by street artists as a *décollage* featuring EMPLOYMENT OPPORTUNITIES—doing what, the sign no longer said. Under the rail bridge and farther east on Cambridge Heath Road, you witnessed a cheerful sign telling you what the council or a developer hoped would happen next: "Making an impact through deeper relationships." (In Islington I once stumbled on a sign offering "real housing for real people"—unreal people, zombies, space aliens, vampires, foxes, cartoons, and fictional characters need not apply!)

The bus discharged old folks and sick people at Homerton Hospital, where they joined the walking wounded circumambulating the NHS facility. The genius of Homerton involved staying snug within a cloak of invisibility. Then came the mysteries of Kingsmead and the estates near the canal. Completing this bus journey, just beyond the Trowbridge Estate, you had the place to yourself. A man you'd never see again paused on crutches with a quizzical look on his face, as if he wasn't certain where to go next. As Spinoza wrote, "By reality and perfection I understand the same thing."

I LIKED THE FEELING of the end of the line. I wanted
to visit the graffiti down by the canal. I had been photo-
graphing the images for nearly a decade, getting hooked
after seeing the street artist Stik's images of families ap-
pear on the concrete girders of an overpass in 2006. On
a journey to this area in 2011, the Olympic Park was still
under construction and fenced off. As I photographed a
sign stuck sideways in the bare earth—CONTAMINATED—
JAPANESE KNOTWEED—a man accosted me from across the
canal near a derelict warehouse.

"Would you eat a fish out of water that looked like this?"
he asked.

I looked down, and saw algae and floating trash.

"No," I said. "Maybe some people don't have a choice?"

My question seemed to please him, although he didn't
answer. I walked away wondering if our encounter had
been filmed. Artists had been swarming the site, trying
to document and offer resistance to the Olympic project
in the wetlands surrounding Stratford. Now I knew what
Banksy looked like, or so I liked to imagine.

What surprised me when I returned to the site was
how much of the area remained under construction a
couple of years after the Olympics were over. Some of
the graffiti hadn't changed or been messed with, not
painted over or destroyed in the natural cycle of street
art. The new graffiti that had appeared along the canal
seemed to have a more menacing cast, at least that's how
it looked to me on that day. It felt hostile—against the
place rather than for it or with it. A skeleton had sex with
a woman, looking back at the viewer as if on camera.

Another tagger had painted in a request for "her digits."
PLAY YOUR PART, read a mocking message scrawled on a
bridge, making fun of the official civic pride concepts
surrounding the Olympic development schemes. TIME TO
REMEMBER floated above a man with a bull's head. Faces of
fear and strange mathematical diagrams emerged from
the brick alongside a classic image, one that had been
there for years, of a totally adorable monster with a blue
and red face and a row of crooked teeth, nose held with
a clothespin.

The building projects at the Olympic site formed part
of the "Legacy" stage of the 2012 Games. The area re-
mained a text still being revised and edited—a collab-
orative corporate document in the cloud—difficult to
interpret. Before the Games, if I recalled correctly, the
local media had prophesied doom. Crowds and bombings,
then wrack and ruin as the tall grass blasted up through
derelict concrete. Iain Sinclair's introduction to *Archaeol-
ogy in Reverse*, a collection of Stephen Gill's photographs,
culled some of the antipastoral jaw-dropping "dirt" of
the area that formed the Olympic development site. "He
haunts the places that haunt him," Sinclair wrote of Gill.
Gill's images of dead swans and detritus floating in the
canals and marshes of Hackney were interposed with
snapshots of David Cameron pacing the area, of build-
ing excavators and parked cars with smashed windows.
In his books Sinclair attacked the plasticky veneering of
London that had continued from the 1980s to the 2010s,
the political slickness of "market forces" that took hold
of the derelict properties near any amount of water in the

city. The Olympic Park became the epicenter of a larger
process happening all over the world. Sinclair wrote an
entire book about the Olympic site, *Ghost Milk*, describ-
ing his project as a "sweat-drenched exorcism." Palpable
hurt dripped off of every page. A common thread in his
writing over the decades had been a very London suspi-
cion of big buildings: Thatcher's 1980s development of
the docklands at Canary Wharf; Blair's folly at the Mil-
lennium Dome (memorably sent up in Sinclair's *Sorry
Meniscus* pamphlet); and the Blair-Cameron "grand proj-
ect" of the Queen Elizabeth Olympic Park.

Revisiting the park, my own impression was that if any-
thing Sinclair actually had underestimated the megalo-
mania of the forces he opposed. These projects appeared
like Mickey Mouse's in the "Sorcerer's Apprentice" seg-
ment of *Fantasia*. Things set in motion built on them-
selves and magically replicated beyond anyone's ability to
control. Sinclair often invoked the British science fiction
writer J. G. Ballard as a patron saint of the postmodern
landscape—the Olympic Park was an unwritten Ballard

novel whose high-rises, car parks, and vertiginous shopping centers existed on a scale designed to accommodate vast crowds of consumers. (But with what money would they shop?) Ballard wrote in his preface to his novel *Crash* that it was no longer necessary to write science fiction about the distant future, since the jarring effects of "sinister technologies" already surrounded us in the present. In his essays Sinclair seemed to take Ballard at his word and simply went one step further, documenting the jagged and bleeding edges of the present.

To me the Olympic Park felt like a virtual reality construct. On the fences of the construction sites, visitors encountered artists' renderings of crowds enjoying fictional cubical restaurants that looked like floating spacecraft. Signs appeared in front of the gravel saying "Beautiful Public Spaces," as if posting this statement made it true. "London's Healthiest Business District Coming Soon." In another area of the park I found a sign in front of a sculpture explaining that this was a "work of art," and therefore not to be climbed on.

In the summer of 2014 the Secret Cinema outfit produced its version of *Back to the Future* here. Muffled booms and special effects of time travel could be heard behind the barriers and scaffolding, where a miniature version of the movie's town square had been recreated for an "immersion experience." Tickets for this extravaganza in austerity London were fifty quid a pop, and demand was enormous. Opening night had been delayed, and though I didn't know it until I walked back to Hackney Wick, I was about to stumble into the participants

for the very first screening. As I made my way back to the bus, I passed crowds of people dolled up in throwback American attire near the train station, waiting for their chance to experience the 1950s through the medium of a film of the 1980s, recast as entertainment in the 2010s.

The metaphor of all this time travel was almost too tidy. The Olympic Park represented the quintessence of how the Blair and Cameron governments aped Thatcher, just as Thatcher and Reagan attempted to conjure up the aura of the 1950s. Fifty pounds probably went a long way in the neighborhoods east of the Olympic Park, but things had been arranged so that the casual visitors didn't stray too far from the bubble. Maybe one day hovercraft tours of the "authentic" estates would be arranged by the authorities. Perhaps the grand project would succeed and everyone without good credit would be banished, ideally to another planet. Construction of instant neighborhoods with eco-friendly features leading east had already begun. And from the Stratford International rail terminal you traveled straight to Paris for the weekend.

The Olympic Park, with its spaceship Aquatic Center designed by Zaha Hadid, and its gleaming layers of tat, remained enchanting, like a nefarious spell. If you stayed here long enough the scale of everything started to provoke a queasy sense of unease, just as Ballard had predicted in his novel *Kingdom Come*, about an evil shopping mall in the far West London suburbs near Heathrow. In the sunshine of a summer afternoon the Olympic Park felt perfectly pleasant and looked totally harmless,

a mecca for kids dashing around in the fountains near the stadium, joggers and families with prams winding through the wetlands, diverse global crowds rubbing elbows in the Westfield Mall, united in their quest for the bowling alley and the multiplex.

It was true that all this felt beamed in. Maybe you couldn't put away the images of Stephen Gill and the graffiti by the canal and the estates of Newham. Distressing things happened to the unconscious mind after nightfall in the empty streets of the former Olympic Village, a ghost town where a wormhole appeared at midnight to transport phantoms between the world's empty IKEA-furnished flats. After dark, the sign reading "Beautiful Public Spaces" revealed itself as a peculiar kind of psychosis—an insistence on delusion and hallucination, on seeing the world as it was not. Instead of being consigned to psychiatric wards, these developers would push their vision into reality until it matched up, their sanity proved. They called it visionary urban planning, on the

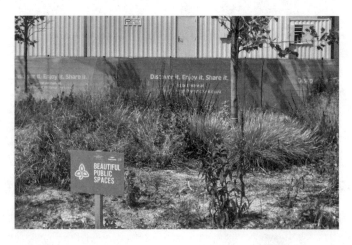

scale of Ayn Rand, but it was also quite mad. You half expected Klaus Kinski to turn up in a filthy white suit and start ranting about building an opera house deep in the marshes.

Surely all this would prove a booming success; artists like Sinclair and Krish preferred to seem dated, anti. What offended them involved the effacement of memory. The goal here wasn't simply to batter a recalcitrant urban area into submission through shock-and-awe building plans. What was really going on, the hidden plan, entailed the construction of a new series of monumental structures, like a new Stonehenge, but on a massive scale that only could be grasped from the vantage point of a helicopter tour. Seen from the air the secret project emerged, a grand processional stretching east from the new skyscrapers of the financial district in the City, out to Canary Wharf, and then to the temple complex and recreation grounds of the Olympic Park. The Aquatic Center became a latter-day Roman Bath combined with an escape pod from Earth in the event of ultimate disaster. Where was the three-faced demon head buried, where was the Queen's crystal skull, where was the underground beneath the underground beneath the Underground where the starships stayed hidden?

In place of Neolithic stones, our architects carefully placed colossal steel buildings along these sites sacred to the culture of Anglo-capitalist mercantile lifeways. Only decades and centuries would tell whether this frenzy of building would come to be seen as an Ozymandias-like attempt at self-aggrandizement, or something that people

could use in their own way. As for myself I became con-
vinced that this scheme already looked too big to fail. The
park would be embraced and it would become its own
strange hive, rather like the concrete mountains and cave
system of the Barbican Center at the edge of the City,
where the mice frolicked in the carpeted halls after hours.
It might take many years but one day this folly—really,
the entire park was at heart a gigantic Victorian Folly (a
folly you could live inside!)—all of it, would look outdated.
At first it would seem hideous, and then one day it might
feel charming again. Its decay would be spectacular.

SCIENCE FICTION offers one sensible way to respond
to this environment. Here's a story of postapocalypse,
dedicated to the Queen Elizabeth Olympic Park. A group
of treasure hunters travels to an empty London recover-
ing from nuclear attack. The Geiger counters are click-
ing off the charts but there's a new technology that allows
for safe encounters with radioactive materials. These
space-age looters have come to raid the vaults of the City
of London, having heard that the silver and gold still re-
main untouched in the deepest underground chambers.
They hover into the city from Gravesend, reversing the
course of Conrad's *Heart of Darkness*, and someone cracks
a joke about how "this too was once one of the dark places
on the earth." The underbrush of humanity having been
cleared away by abandonment and neglect, the landmarks
that guide them into London are the ruins of the West-
field Mall at Stratford, the collapsed pyramid of the HSBC
Tower overlooking the Thames at Canary Wharf, and the

geometrical wonder of the Gherkin, which even devoid of its windows remains an impressive site on the vacant horizon.

At great personal cost, including the loss of minor crew, the treasure seekers finally penetrate the bank vaults only to discover that the silver and gold are long gone, and that the only thing remaining to steal is a billion pounds of obsolete Sterling notes, which are completely worthless in the *Dune*-like economy of water and precious metals that reigns in the future. Someone mutters about how in the late twenty-first century paper money gave way entirely to a digital system of commerce where trillions zapped around the globe in dematerialized terabytes of data, virtual wealth that proved all too easy to wipe out without a trace because the money never existed any-where in the real world.

ALCHEMY
& GRAVITY

ON A RAINY WINTER DAY before her departure for
Spain, I showed my wife around the Olympic Park. Maybe
it was the weather or my gloom about Emily's imminent
departure, but the spell cast by the place had been broken.

"Terrifying," she said, as we walked around the mall,
the adjacent pop-up neighborhoods, and the aspirational
signage. "It looks like something they'd build in Orange
County. Only, you know, without the sunshine."

We walked in the soaking rain by ourselves along the
vast empty footpaths crisscrossing the marshes. The
paths had been designed for massive crowds during the
Games—dozens of people could walk abreast at the pe-
destrian crossings on the roads—and this monumental
scale made the place feel absurdist. These giants' cause-
ways led to coffee at the Timber Lodge, where a glossy
brochure advertised basketball between the London
Lions and the Iowa Hawkeyes. We found a book ex-
change in the café; some local wit had placed a volume
there about cinema and voyeurism with a big eye on the
front cover, but I couldn't nab it because I hadn't brought
anything to leave in its place.

"So," I said, "there's a place I'd like to visit . . . Love Lane in Woodford Green."

"Why?" Emily said. "It's nice and warm in this café."

"We could walk through the marshes up to Leyton and catch the bus."

"You remember that's where I used to ride my motorbike, before I wrecked it? Up in Epping Forest."

"What happened?"

"Some guy cut me off," she said. "The bike got totaled."

Although neither one of us mentioned it, we both knew that she had bought the bike and traveled to that part of the suburbs to visit her boyfriend at the time, a bad drinker. Everyone became overbearingly worried about Emily when she went with him. One of his friends used to begin his visits to her flat by scouring the cabinets for drink and gulping down whatever was on hand. They'd go to lock-ins or illegal raves where Emily watched acquaintances melt down on ketamine. Her boyfriend would claim he was done drinking, but the next morning Emily would find miniature bottles in the recycling bins outside the flat. The guy tolerated me despite my obvious interest in Emily, but one day he asked me how I thought I might get on in prison. In any event this was a part of her life she didn't like to talk about.

"I could go up there another time by myself," I said.

"You've got me slightly curious. How long on the bus?"

"We could take the Tube instead, but we'd miss everything in between."

And by "everything" I meant the splendors of Wanstead, the North Circular Road, the River Roding, the M11, and

the mansion houses of Greater London. These were the icy objects of the distant reaches of outer space, as far as my cognitive map of London was concerned. I'd never met anyone other than Emily who would even consider taking such a journey with me.

"There might be nothing there," I said.

"Well," she said. "There's always *something* there."

When we arrived at Love Lane in Woodford Green, we discovered that it looked a lot like one of the movie locations from the documentary I was dreaming about, Robert Vas's *Refuge England*. Just another suburban street winding up a little hill toward the grounds of the Chigwell Convent Chapel. I never could be certain that Vas had filmed there, but the houses had a similar look about them. I located number 25—the address that appeared in the film—and fired off a few snapshots. A little loop completed. Without truly understanding what I was doing there, I was performing some kind of ritual, visiting a series of imaginary shrines, looking for answers in old movies. Twenty years of wandering this city together, off and on, and everything we had ever said to one another condensed into this single day.

"Aren't you going to knock on the door?" Emily said, teasing me.

"What would I say?"

"Ask if it's a nice place to raise a family. Tell them you're thinking of relocating."

"Are we?"

"You like my country," she said, "but I prefer yours."

The fastest way back to Finsbury Park Station went

through Walthamstow, but that would involve yet another bus journey. On the Tube from Chigwell we could stay on the Underground, keep warm, and dry out. That would mean traveling all the way back into Central London via Stratford. The total journey time, surprisingly, wouldn't be all that different, maybe an additional fifteen minutes or so. The Olympic Park warped the space-time continuum. It would speed up our spaceship as we boomeranged around its gravitational pull and shot into Zone 1. And then home to the kettle and the duvet and the telly. Later on we watched Brits burning through their life savings on mad restaurant schemes in Gordon Ramsay's television series *Costa del Nightmares*. Midway through the broadcast I realized that Emily loved Spain because she was still English, somewhere deep down.

UNREAL

CITY

THE
MAYAN
CALENDAR

"WE SEEMED to be attempting to travel through time,"
Patrick Keiller suggested in his explorations of Piccadilly
Circus and environs for his 1994 film *London*. In this
city time travel happens every day. During my summer
visit in 2014, a lot of multiple histories and timelines
started colliding. The overall effect felt a little bit like the
various cogs and wheels said to converge on the Mayan
Calendar. The media's obsession with "On This Day" an-
niversaries and commemorations provided little hooks
on which to hang a story that would self-destruct after
twenty-four hours, but also the chance to live perma-
nently in the past. Historical events accelerated toward
the present on both sides of the Atlantic. Back home, the
Civil War had reached a new frenzy of slaughter in 1864
Virginia, bloodying places like Spotsylvania and Cold
Harbor; the British had long since decided not to aid
the Confederacy, much as the Crown might have liked
to irk the United States. Meanwhile in another timeline
altogether the British had burned down Washington in
the War of 1812, which had carried on until 1814, awk-
wardly for the namers of events. Fast-forward in time,

and Allied troops had begun landing on French beaches on D-Day in the summer of 1944. It was the year of 4s. In the UK however the D-Day commemorations quickly gave way to supersaturated coverage of the one-hundred-year remembrances of World War I. British involvement had begun exactly a century prior. I had read about a candle-lighting ceremony at Westminster Abbey. As the hour struck on August 4, all the lights in London were supposed to be turned off out of respect for the war dead.

For me this proposed citywide blackout was all about getting out of the Glow, leaving the phone zombies walking hunched over their screens. I wanted to meet the world halfway. Just me and my notebook, alone in this city. Passing through Charing Cross Station, I thought about the boat trains that had brought crowds of German working-men back home to the Continent in 1914 in order to fight the British in France. The British government, oddly, let them go but interned German civilians who stayed behind

in London at Alexandra Palace. Taking a detour to ram-
ble around Green Park, I passed the Ritz, where French
and German waiters left their posts due to conscription
or "war fever." The Theatre District splashed inevitable
advertisements for *War Horse*. In two hours the candles
would be lit and then go out again one by one at midnight.

Before entering the park, I stopped in Piccadilly Cir-
cus. I felt it was finally time for me to get to grips with
this place, which I had never understood and had always
avoided. Giant neon screens advised me to Share a Coke
with Faisel. Not the worst idea in the world. Everyone
from everywhere snapped selfies and posed in the gen-
eral jumble under an awning advertising *The 39 Steps*—
evil Germans again! Everybody here shot everyone else,
harmlessly, with their camera phones. I wondered how
much had changed since Keiller had filmed in this area
(yet another anniversary to mark—*London*'s twentieth),
trawling the cinemas of Leicester Square, capturing a
Cinerama poster, and turning the camera away from the
sights and back on the tourists themselves. Keiller's nar-
rator said that his research involved "exercises in psychic
landscaping, drifting, and free association."

Suppose I confessed my secret belief that tourism rep-
resented the salvation of the world? How many strangers'
snapshots and home videos of London had I appeared in
over the years in countless unknown cameos? It would
be strange to glimpse an archive of all those instants, a
kind of mosaic of worldwide travelers' lives intersecting
for a moment, everyone connected by my face lurking in
the background.

An LBC radio reporter interviewed a passing couple under the aegis of the Cupid statue at the center of the Circus, asking them if they thought it was "important to remember" this day in 1914 when Britain joined the war. How could anyone answer such a question? The reporter told the couple that for the first time ever the screens of Piccadilly would be used for another purpose than advertising this evening, to screen an honor roll of photographs and names from the Great War. I wanted to see that. Even the 1945 photos of V-J Day in Piccadilly had featured Bovril and Schweppes Tonic Water.

"This really is a dirty part of London," noted a polished-looking Indian tourist to her family as they posed in front of the statue of Eros. "Is Harrods nearby?"

Piccadilly Circus always thronged with crowds even though there was absolutely nothing to visit. For years I had tried to understand this phenomenon, completely flummoxed. The so-what-ness of the place defied description—just a traffic circle suffocating in fumes where the statue of Love floated with his bow and arrow below the electronic billboards. The spot provided a good meeting point in the Theatre District, presumably, a piazza without an Italian city around it, a Mecca without anything to worship. It was a place without glamour at which people insisted on being photographed. London had taken you hostage and here was your proof of life. Maybe Piccadilly Circus hid the entrance to another dimension or contained a spell that magnetized pollution and crowds. Actually just being there made everyone into a movie star in an endless film by Andy Warhol.

As night fell, I tried to reproduce some of the shots from the 1957 Free Cinema gem *Nice Time*. This short film by Claude Goretta and Alain Tanner had always intrigued me for its connections with Pop Art and its insistence on pedestrian forms of lewdness. (It revealed Piccadilly Circus as an old-fashioned Times Square, with a cinema awning advertising SHOCKER CERT X). In *Nice Time* movie soundtracks of romantic films overlay images of couples queuing for the pictures. Eruptions of fake Hollywood gunfire spliced sight and sound with a wartime vet hawking newspapers, no nose and one eye. Junk and entrancement, snacks and flowers, NUDITA (LA BELLE FRANCE) and high heels. Cameos by drunken sailors arranging tricks in stolen footage. The protagonist from *Refuge England*, Robert Vas's refugee newly landed in London, had passed through Piccadilly Circus as well, if you remembered the footage correctly. "There is no other place," he said. "You have to live here. You have to live here." Back to *Nice Time*: pinball, jukeboxes, neon, and visions of dreamy sex kittens. "God Save the Queen" played over the Coca-Cola sign. FLEE FROM THE WRATH TO COME read a sign carried through streets. Piccadilly Circus finally abandoned in the small hours with a poignant and oddly fitting rendition of "Till Our Wedding Day."

One memorable shot from *Nice Time* twirled around the Cupid statue, glimpsing the idlers quickly in passing. It could have been filmed from a moving car. I always loused up my own pictures. A world of difference lay between the strolling informality of a documentary *dèrive* and my junky snapshots. Maybe it was the constant pres-

ence of other camera phones held aloft, but my effects felt botched. My images needed to age for at least fifty years, to get scuffed up by time, before they had a chance of yielding up anything interesting. Maybe they would spot an Icarus in these pictures, plopping into the sea in an unnoted corner of the canvas.

I took a walk past the memorials to Lord Such-and-Such and an ominous statue commemorating the Crimean War. Walking through the plane trees of Green Park toward Westminster Abbey and the official candle-lighting ceremony, I passed by a set of placards showing heaps of shells and blasted landscapes, the World War I wreckage of European fields that spawned more and greater ruin, including here in London. I darted past the Churchill War Rooms at dusk and down to the abbey, just to confirm my suspicion that the candle lighting listed in the papers was not open to the public. Crowds lined the streets calling out to one another: "Ambassador!" and

"something something Charles and Camilla something." Under television lights a journalist interviewed a person who looked a little bit like then–deputy prime minister and Tory coalition government partner Nick Clegg, with the splendor of the abbey arrayed behind him. I came close enough to launch an egg or to shout out encouragement to the loneliest man in Britain. But my eyesight was notoriously bad, I'm sure it wasn't him, and besides, this wasn't my country.

By the time I jogged back to Piccadilly Circus, lights-out was being observed already on the gigantic screens by projecting images from World War I instead of adverts for Samsung. Images of falling poppies and a list of names reflected in the crowd's upturned faces. For a minute or two the signals on the screens got mixed up, so that "Share a Coke With . . ." appeared over the head of a Great War soldier in sepia tones. It was a baffling sight, to be sure, but one that felt sweet and fitting in its own way.

SUGGESTED
ITINERARY

Dear _____,

Your questions about what to see in London as a first-time American tourist are difficult for me to answer. I'm certain most visitors don't want to browse one-pound paperbacks and odd dishware in charity shops, or walk along the industrial remnants of the docks at night leading to the Thames Flood Barrier, or visit the Victorian sewage works that saved Tottenham from cholera.

But if I were in London only for a few days and I wasn't certain I would ever return, this is one walk I would take. I suggest starting at the Museum of London—admission by donation and well worth an orientation visit to see remnants of the Roman Wall and to explore the layers of the city from prehistoric tools to the present. (Check out the wartime photos of American GIs and their English girlfriends kissing in the park or posing at Frisco's, a dancing spot where black soldiers found a welcome.) While you're in the area, walk through the Postman's Park between St. Martin's Le Grand and King Edward Street; you'll find a monument in tile dedicated to Londoners who have died giving their lives to save others,

in many cases from the Thames. From here it's a ten-minute walk south to St. Paul's Cathedral (check).

Now you are ready to cross the river over the London Millennium Footbridge (check), where you will be forced to form an opinion about humanity's greatest invention. I do not mean Norman Foster and Anthony Caro's ingenious suspension bridge, or St. Paul's, or the Tate Modern at the old Bankside Power Station, or the replica of Shakespeare's Globe along the South Bank, or the Thames Flood Barrier (which cannot be seen from here, but which, as you'll notice if it is high tide, keeps parts of London from becoming a seasonal swamp). No, I am referring to the selfie stick, that pinnacle of post-postmodern ingenuity and the magic wand of the emerging global aesthetic of faux-naive technonarcissism. The selfie stick allows tourists to watch themselves watching their smartphone while it takes pictures of them, and all without asking a stranger to intervene. I am strongly in favor of the selfie stick. The reason is that we tourists are clowns by definition—our role should be to entertain locals with our antics, not to try to fit in but rather to stand out as the assful and ludicrous creatures that we become when we leave our pond and swim in someone else's. At least the selfie stick tells us the truth about ourselves.

I have a feeling that you might get hungry on this walk, especially if you are stopping at the Tate Modern (check) and glancing around Shakespeare's Globe (check). If you can hold off on museum café food and continue along Bankside, there's a reward waiting at Borough Market. Street food, gourmet niblets, international flavors, sangria,

pâté, espresso, and tons of stuff to fortify you for the rest of the day: it's all here in a little warren of stalls, everything sweet and savory. A great point of charm for me is eating at the market and then visiting the cats who stalk the grounds of the adjacent Southwark Cathedral. They sleep in little padded cushions in nooks inside the cathedral. Please forward my greetings!

From Borough Market you can continue walking east along the river toward the Tower of London (check) and Tower Bridge (check). While you're there, you might form an opinion about the new skyscrapers that have been built in recent years across the river in the City's financial district. These buildings have funny local nicknames— the Walkie-Talkie, the Cheesegrater, etc.—designed to disguise how creepy they really look. One newer project on the south side of the river, One Tower Bridge, looks down on a concrete park covering the old potter's field. Metaphorical perfection: at the feet of the global elite the ancient resting place for the anonymous bones of the destitute. By now you've passed another weird building on the south side of the Thames, the lopsided giant orb of City Hall, which I like to call the Crystal Skull.

So here you are at Tower Bridge. May it open for you; seeing the drawbridge rising is a lucky chance if you have the maritime bug. A visit to the Tower of London: jesting Beefeaters in antique costumes (check); ghastly executions and imprisonments (check); royal jewels, crowns, scepters, and the like (check); creepy ravens (check); turrets, walls, towers, and other DROSS (Dramatic Really Old Stone Stuff) (check). While you're here, take a detour

along the yachts moored at St. Katharine Docks, which also feature the sight of a Starbucks shaped like a circular Greek temple, surely the eighth wonder of the world. You might not have the time but it would be irresponsible of me not to suggest that you keep walking east from here, along the footpath on the Ornamental Canal leading to Shadwell Basin and onward toward Limehouse Basin, or along the riverside in Wapping to the haunts of Dickens and Whistler, or north to Swedenborg Gardens, the mural commemorating the Battle of Cable Street, and then to Whitechapel, Spitalfields, and the Barbican Centre. Or from Limehouse Basin to Victoria Park, and then to the Angel, along the old canal system. Or from Limehouse through the Isle of Dogs to the foot tunnel and over to Greenwich. I am sorry, I am getting carried away. When I am in London, I just like to follow one body of water to the next through the city, searching for breathable air.

TOGETHER
& ALONE

I TRIED TO RECREATE John Ford's lost or faked short Free Cinema film *So Alone* several times by bringing friends to Wapping, where it was supposedly shot on location in the winter of 1957 and released in 1958 by the British Film Institute. The scenario of this cinematic ghost involved "the relationship between (and incidents in the life of) two men as they wander through Wapping on a cold winter day." But nobody ever had located the movie, and others believed it to be a total hoax, removing it from later Ford filmographies.

The plot of *So Alone* echoes another Free Cinema production, *Together*, completed the year before, directed by Lorenza Mazzetti and written by Denis Horne. (Walter Lassally provided additional photography for the film, while Lindsay Anderson offered his services to Mazzetti as supervising editor.) *Together* tells the story of two deaf men living in the East End. They encounter fear and prejudice because of their disability. One of the men ends up drowned in a docklands canal after falling off a bridge. He's the victim of a child's prank. The kid sneaks up on him while he's looking into the water. The child taps him

on the back and he accidentally falls to his death. His friend returns to the bridge to try to find him, but he cannot hear his cries for help below, in the water. Images of a dredger taking up slime from the bottom of the canal seal the film. *Together* is dedicated to "the people of East London," yet they are portrayed as unfriendly to the deaf men, who work as box handlers in a docklands warehouse across the river from Wapping and live in a boarding house in a blasted zone of the city. Groups of feral children harass them in the rubble, chanting racist schoolyard rhymes and openly mocking the police.

Together was a loosely articulated fiction feature film—with actors playing at being deaf—but its documentary value lay in recording the seediness of the London slums in the mid-1950s, making its raw footage extraordinary. The film revealed exploded neighborhoods left by World War II, a no-man's-land of vacant lots and windowless brick remnants of houses. *Together* toured the back alleys of the industrial zones near Butler's Wharf and screened the cramped rooms, battered street markets, and filthy skylines of the docks and the canals. Grimy faces in the pubs mixed unforgettably with the bafflement of the deaf men as the film went suddenly silent (years before Godard's famous "minute of silence" in *Band of Outsiders*) to suggest what life might be like for the characters. The jarring sounds of the streets and London's manufacturing industries aren't all that much to look forward to when the sound switches back on.

Together did make use of a preferred John Ford technique, showing people with memorable mugs in close-

ups. Yet despite the similarities in their storylines (the relationship between and incidents in the lives of two men in Wapping, etc.) and despite their mirror-image titles—*Together* and *So Alone*—no clear evidence ever emerged that John Ford filmed the latter. It was difficult to think of any reason why Ford would have wanted to remake a condensed version of *Together* one year later, substituting street musicians for the deaf men and, according to the credits listed for *So Alone*, using Walter Lassally as his cameraman. (In his autobiography Lassally described his work on *Together* and mentioned Ford repeatedly as a major influence; if they had ever really worked together on a film, Lassally surely would have mentioned it.) *So Alone* first appeared as a joke or hidden puzzle in Peter Bogdanovich's 1968 book *John Ford* in an accompanying filmography researched by Polly Platt. Ford scholar Bill Levy in his *John Ford: A Bio-bibliography* calls *So Alone* either a "hoax" or an "unrealized project." If it was an unrealized project, Ford planned it during his visit to London to film on location for his 1959 police story, *Gideon of Scotland Yard* (aka *Gideon's Day*). Ford's detective, George Gideon, was a suave chap in a good suit who juggled escaped mental patients, bank robbers, corrupt officers, and his daughter's violin performance at the Royal College of Music. What Gideon hated most of all was a "rich nobody."

During that visit, Anderson, who idolized Ford, persuaded the great American auteur to attend a screening of Anderson's Free Cinema documentary *Every Day except Christmas* by offering it in a double bill with Eisenstein's

Ivan the Terrible, which Ford had never seen. Anderson later wrote in his 1981 book *About John Ford* that

> Ford's viewing of *Every Day Except Christmas* at the National Film Theatre was the nearest he came to contact with our Free Cinema movement of those days. But it seems to have given rise to a choice item of Fordian mythology. The Filmography in Peter Bogdanovich's monograph lists the following entry for 1958: "So Alone (Free Cinema—British Film Institute.) Director: John Ford." This film, which never existed, seems to be a leg-pull in the best Fordian tradition. . . . The notion of *So Alone* as Ford's contribution to Free Cinema is delightfully absurd—perhaps there was even a touch of friendliness in the joke.

This passage, as far as I know, was as close as Anderson ever came to admitting that he knew about the hoax that Ford had made a Free Cinema film during his spare time while visiting London. It remains unknown whether Ford himself was in on the joke, as Anderson implies, or if Bogdanovich was the victim or yet another co-conspirator in the joke. Anderson's ironclad confidence that the film "never existed" might be viewed as a sort of confession.

The scenario for *So Alone* is a tempting subject for a very short film: two men wandering through the urban fabric on a freezing day. The movie is supposed to be about their relationship. I would love to see an anthology of shorts produced by great directors, each of whom would have to recreate *So Alone* based on this bare-bones

premise. They would work in a compartmentalized fashion so that none of the directors knew what the others were doing, of course. Perhaps they would have to recycle the same actors. They would develop their own script and film in the same locations.

On more than one occasion I tried to drag friends to Wapping and attempted to convince them to let me film them there. I told them about *So Alone* and asked them to invent a story on the spot embroidering on the film's basic storyline. When that failed, I just asked them about their own lives. Most of my friends hated this. The footage turned out bad. I didn't know what I was doing behind the "camera" (in reality just a cheap little camera phone), and the technical aspects of these shorts were universally crummy. I left with memories much more interesting than the actual films produced. In one of these productions I created a sort of flip book of stills at dusk as I pursued a beautiful woman through the streets—in the fading sepia light she blurred like a ghost. It was my wife returning to the spot at Wapping Old Stairs where her parents turned down the opportunity to buy a flat on the river for less than thirty thousand pounds in the 1970s. Another one of my amateur productions featured an American novelist, my friend Skip Horack, drinking at the Town of Ramsgate Pub on a little wooden deck overlooking the river near the spot where Whistler once drew the Wapping river police station. I was about to talk Horack into an epic walk from the Thames through Whitechapel and Hackney to Victoria Park and the canals leading, eventually, to the Angel in Islington several hours later.

Yet another attempt to shoot the picture featured my best pal in London, Ben. We'd been corridor mates at Cambridge and he now studied performance. Apart from his university years and a spell in New York, he had lived in London all of his life. He claimed never to have seen St. Katharine Docks or the canal walk connecting it to Shadwell Basin. (I assumed he was putting me on.) He proved game for filming, but his ruminations on his life and London (he was tired of neither) got cut short when my phone ran out of memory to store the footage. I had exceeded the eight-minute limit set by *So Alone* and wound up with a worthless digital file.

At Shadwell Basin, Ben and I watched a group of fearless young men diving into the water and traced the line of sight between the Shard skyscraper and the Canary Wharf development further out in the docklands. Ben inveighed against the new skyline and tall buildings being planned across London—"I've seen the plans, and they're all horrible!" We passed through the Wapping of Rupert Murdoch's old News International plant, the presses long since stopped, new developments sprouting up along the canal. We mused on our memories of the London riots of 2011, which we'd watched together, largely on television, from the safe distance of Ben's window while police cars streaked by below. I had recorded images off of the television consisting of CCTV footage of shops being looted. I wondered who actually owned this stolen footage of a ripping of a ripping of a ripping. BANKERS DID THIS was a message scrawled on a burnt-out building I visited in Tottenham a few days after the riots

when the high street was reopened. The topic came up because Wapping and environs were known for riots—the Coal Riots of 1798, the post–World War I race riots directed against East End minorities by demobilized soldiers, and the Wapping "dispute" of 1984, during which Murdoch broke the printers' union after they struck to protest the move of the News International presses out of the area. "Any action expected in Wapping tonight?" one Twitter user wanted to know in August 2011, using the hashtag #londonriots.

The newer developments of flats that lined the Thames at Wapping were designed like office buildings. The contemporary style dictated that your apartment building looked like a corporate park, your office looked like a university campus, your university campus looked like a government installation, government buildings looked like museums, and museums looked like abandoned factories.

The most interesting part of our journey limned the invisible dividing line between the tourist zones around Tower Bridge and Shadwell, with its mellow little parks, its Hawksmoor church, the mural commemorating the 1936 anti-Fascist Battle of Cable Street in the East End, and the Muslim-owned shops and markets around the rail station. A group of Asian kids that shouted at us while I was filming Ben turned out to be very friendly. They called out "London, London!" in the hopes that we would turn the camera on them.

The following year, when I was by myself in London and my wife was in Spain, I returned to Wapping and

tried filming yet another version of *So Alone* in the dead of winter. I created failed clips of empty parks, the sound of bleak wind scraping the plane trees and mausoleums in the local cemetery, and of the water lapping at the stone steps leading down to the river. I revisited the narrow alley between the Town of Ramsgate and the adjacent houses that offered public access to the acrid waters. Every time I visited this spot, I thought of the description of the corpse being dredged out of the Thames by the waterman and his daughter in the opening chapter of Dickens's *Our Mutual Friend*. But the problem that Wapping presented now was entirely new—a lack of narrative, a peculiar emptiness. It contained a black hole drained of light and time and substance. Wapping had been scrubbed to a clean death, while the epic novel of London had probably moved into Shadwell and Limehouse to be written by the local young writers of a wildly diverse future. This wasn't my story to tell.

I never figured out a really good scenario for the script of *So Alone*. Eight minutes of film. The weather on the docklands would be cold. The main characters must be musicians. They discuss their relationship and the incidents in their lives. Maybe one of them is much more successful at busking than the other, so they pool their resources at the end of the day for a room in a hostel and a few pints. The talented one claims he plays a valuable violin—not a Stradivarius but along similar lines—that could be exchanged for a house if the musician wanted one. The other busker listens as the story of the instrument unfolds. From certain cues the viewer can tell that

both men know the story is not true, and that they are playing a game to see who can invent the most outlandish secret history for the violin. It was looted from an Italian castle during the war. It had been exchanged for passage out of Nazi Germany. The violin is both magical and cursed—it will allow anyone to play it beautifully without any musical training, but it only works out of doors in cold weather on the worst streets, so that its musician is kept in perpetual poverty. The violin actually plays itself; one's fingers never touch the strings. Its notes make plants grow more quickly and cause birds to gather in trees around it. If you play it out on the river, fish leap into your boat of their own accord to be nearer to the music. Or it's a violin that lets the dead back into the world. It's connected to other dimensions that exist on the far side of the universe.

Free Cinema was never so outlandish, never really about the plot. Its stories were always designed to send the camera through the streets, picking up whatever might be happening on an average day. It was part of that great unsung tradition of movies in which chance sometimes entered the frame and where something wonderful and unrepeatable that happened on one particular day would be preserved forever. The secret connection between documentary and science fiction involved time travel. All my Wapping films were failures because I had tried too hard to import a story of my own into the place instead of letting it speak for itself in the way that Dickens, Whistler, and Woolf had done in their jaunts to the docklands. The same was true of the more intrigu-

ing passages in *Together*. A good cameraman would have turned his lens on the youths who got interested in us, asking them what life was like for them, here and now. It was that risk of contact that made a documentary worth viewing, but I was so focused on recreating *So Alone* that I forgot this basic rule.

About a month after our walk in Wapping, Ben wound up in a hospital ward at St. Thomas's in a bed overlooking the Thames and the Houses of Parliament. He'd returned to the hospital where he'd been born. The best view in London, it turned out, came courtesy of the NHS. His diagnosis was acute appendicitis, but it was obvious what had really happened to him. Like any other native Londoner, his health began to deteriorate from the moment he crossed the river, in the wilderness thirty minutes on foot from his home in Lambeth.

WATCHING

I GOT KNOCKED INTO BED for a week with a vicious flu and my brain cooked itself in an attempt to keep my body alive for another year or two. I sweated heavily into my duvet and watched endless hours of English television. I felt so weak that the most energetic thing I could do was press buttons, on the electric kettle and the cable remote. One game with the remote—Couch Potato Surrealist—involved changing the channel at precisely the right moment in order to create transitory audiovisual collages of accidentally meaningful juxtapositions. On BBC Parliament failed Tory prime ministerial candidate Iain Duncan Smith rose to sneer at a Labour proposal guaranteeing a job to anyone who had been out of work for a year or more. I clicked over to an advert for a payday loan company named after a fruit that you divided into sections, like your installments, with interest rates listed in fine print at the bottom of the screen that would make a loan shark blush. The come-hither looks of the women from everywhere who undressed for onscreen chats melded with other lurid fantasies, the sunny vacation rentals with "guaranteed swimming pools," and the

relentless property shows. My addled perception conflated Sky Television with the entire Anglosphere, from London to Hollywood and Melbourne—*Eastenders, NCIS Los Angeles, Neighbors, Locked Up Abroad.* Gibraltar and Malta, Delhi and Diego Garcia, New York and New South Wales, Kenya and Kentucky. Click, click, click.

Londoners had their native language relayed back to them via satellite transmissions from across the globe, set by the BBC News channel to a pulsing electronica dance beat. Listening to English spoken by people on television from former colonies, especially Americans, must have been a little bit like seeing one's own image in a funhouse mirror, or like recognizing a long-lost cousin as they blundered around in your home uninvited.

My fever got so bad that it felt like the shape of my skull had changed. This was it—it was finally happening. I would become an American werewolf in London, burst out of my skin, grow claws and fangs, and prowl the streets looking for someone to devour, like in the John Landis movie. Wasn't that what Americans really were, werewolves, our public smiles hiding our hideous transformations, our uncontrollable inner need to bay at the moon? For some reason I remembered a Scottish innkeeper on the Isle of Skye who had invited me to tag along on his fishing boat. After we'd returned from the sea, he told me, "You're one of the better ones." That is the right and proper way to address a werewolf if you ever encounter one. In the Landis movie a measure of salvation came in the inevitable form of a pretty English nurse. Maybe she would reach out of the screen and touch my fore-

head, admonish me to buck up. All things are possible if
you are ill enough. I wanted to watch that movie again—
it contained some weird truths wrapped inside silly jokes
and 1980s gore—but I felt too ill to follow even the most
basic plotline. Just contemplating standing up to search
through the DVDs in the next room became a mental
process that transpired for half an hour. Only television
could save me from staring at the wall all day, wondering
if I would finally reach the tipping point at which I truly
wished to die, alone, like a mouse in the floorboards.
This evil London flu ate my bones for a week that felt
like a year. I believed at that moment (part of me believes
it still) an idea that I had probably picked up in a show
I'd seen or a science fiction story I'd read as a teenager.
The reason why the superintelligent extraterrestrials al-
lowed us to continue to live, the reason why the aliens or
the time travelers didn't wipe us out, was that they were
hooked on the same shows we watched and they wanted
to keep tuning in forever in order to find out what hap-
pened in the next episode. I changed the channel and
embarked on the epic saga of making another cup of hot
lemon with plenty of honey. My brain had melted down
like a spent fuel rod. Most of all I needed to watch the
judges on *The Voice* tell each and every contestant that
they were really lovely people, deep down inside, despite
their singing.

VANISHING
STREETS

THE GREAT STREET PHOTOGRAPHER Vivian Maier, who documented Chicago from the bottom up, once called herself "a sort of spy." I started off one afternoon's ramble near Liverpool Street Station, the secret hiding place of counterintelligence wizard George Smiley in John le Carré's *Tinker Tailor Soldier Spy*. During his stint at the Hotel Islay, Smiley retreated to hunt and trap the Communist mole plaguing British Intelligence during the baroque phase of the Cold War. (As it happened, the real-life KGB double agents that le Carré drew on for his novel were first recruited at my old Cambridge college.) Because the Hotel Islay probably never existed, it proved an easy task not to find it on a location scout around the milling crowds, Victorian facades, and post-work pubs. Surely Smiley's ghost was up there in a window somewhere, calculating, sublime in his paranoia. He would unravel all plots.

From this spot it was a quick jaunt to Chicksand Street, where Bram Stoker set the location of one of Dracula's many London coffins. (Smiley would have sniffed him out—perhaps a graphic novelist has drawn a Smiley vs.

Dracula comic about the East End?) This area—poverty stricken in Stoker's time—was a provocative site to write about insofar as it reinforced the novelist's peculiar psychosexual horror of forces from Eastern Europe. The fear of foreigners that warped Stoker's novel settled on that exquisite Victorian agony over what happened to men and women in the interval between engagement and marriage. A monster rose to contaminate the city through its dark windows and back gardens. The story involved the frenzied blood of lust-crazed men who lived in terror of their beloved's carnality before the wedding night. The idea that one's spouse was secretly depraved and hiding their diseases found a focal point in the streets of a Victorian red-light district and notorious slum.

Around here one encountered the clichés of the box-ticking East End itinerary: Victorian crime scenes on Hanbury Street; plaques commemorating the remnants of the Jewish East End on Princelet Street; Banglatown and Brick Lane; Whitechapel Market; gangster pubs reputed to hold various bullet holes; and so on. In her splendid book *On Brick Lane* the London artist and writer Rachel Lichtenstein warned her readers against falling prey to this woefully outdated version of East London's history. "Brick Lane continues to be rewritten and reimagined," she wrote,

> but primarily with a focus on the violent and grim aspects of its history. Magazine features and television programmes report repeatedly about heroin addiction and gang warfare. Novels revel in the poverty of the area

and Ripper Tours help to keep visitors' dark preconceptions confirmed. I have attempted in this book to bring to light some of the quieter but no less remarkable stories of the people who have lived and worked in Brick Lane. So many memories of this street have already been erased or forgotten: hidden behind newly erected buildings, buried under recently paved streets like unexcavated archeological treasures.

Blasting through the accretions of mythology and fiction, Lichtenstein pinpointed a peculiar morbidity endemic to representations of London. It was that odd chamber of horrors theme-park mentality represented by the London Dungeon, where the minimum-wage ghouls could be seen resting outside on their cigarette breaks. The torture house as tourist attraction (heartily emphasized by the Beefeaters at the "Bloody Tower"). The execution spot and the crime scene as "points of interest" on after-dark walking tours touted by actors in period costumes. The Websterian relish of London's Grand Guignol.

The East End occupied an especially obnoxious place in the pantheon of this very English sort of *London after Midnight* / Hammer Horror / Lon Chaney / *Black Sabbath* / Alfred Hitchcock / *Ripper Street* / *Luther* style of entertainment. A well-dressed man or a provocative woman in a corset with a hammy demeanor entertained and terrified you simultaneously with his or her sinister smile—and salacious annotations. The attractions for outsiders included the dead and the undead. If you visited anyplace where tax receipts were flagging, you'd find the propri-

etors of haunted houses. What you learned on your vacation was that all sorts of horrible stuff went down.

Lichtenstein's reclamation project on the past and present of the East End aligned her with the elegiac tradition of London writers, filmmakers, and artists as well as with the London obsession for local history and psychological topography, of microhistory buffs and talk-your-ear-off guides whose lives were consumed by the traces of the past. These mediums channeled the voices of the ordinary and collected maps, documents, and bric-a-brac for future museums of everyday life. Their apotheosis lay in reenchanting banalities.

Lichtenstein's book described the terminology the locals had for some of the newer residents of the East End. The "haircuts" were those moving into the condos and boutique shopping districts around Spitalfields. Reading about Lichtenstein's encounters with American tourists in the Whitechapel Library, I was easily embarrassed into silence about this densely storied district. But my personal quest to visit London documentary locations led me to this area in search of Hessel Street, the location for and subject of Robert Vas's unforgettable 1962 short film *The Vanishing Street*, about the Jewish East End. The film documented a living corner of the city in the process of being erased.

Vas's film felt grief-stricken about what it witnessed. The camera recorded the kosher markets, but it imposed the surveyor's sighting equipment over its shots of Hessel Street so that the audience understood much of what they saw was about to disappear. Ambient conversations

in Yiddish and haunting images of children playing on ropes in an abandoned house of worship bookended with models of the "space age" 1960s tower blocks that would land on the neighborhood after the bulldozers swept through. Vas captured the ephemeral and the marginalized, insisting on the dignity of people, buildings, places, and things that others considered disposable impediments to progress.

Ironically, these same types of tower blocks, considered London's biggest eyesores to some, had themselves become the buildings slated for demolition across the city. If Vas were filming more recently he might have found his subject matter in the very buildings he once lamented, in the crumbling margins left over from postwar visions of the modern. An urban theorist's pamphlet on this topic could be called *Horrible Buildings: In Praise of the Unsightly*. It would focus on things supposedly not worth looking at.

The estates near Hessel Street stood for the time being, tucked out of view from the more traveled areas along the Whitechapel High Street. As I walked along Hessel Street, now more or less a back alley connecting the estates with Commercial Road, I encountered halal butchers and wholesale clothing shops, their back lots adorned with "Don't Throw Rubbish."

On the Street View of Google Maps, a strangely fitting lens whose time traveling always brings the viewer back a year or two, brick buildings were being rehabbed above the blurred-out heads of passersby whose identities got smudged out. At 42 Hessel Street, Google placed a self-

referential nod in the form of the visible shadow of the Street View camera itself. At the next click, 54 Hessel, the internet browser sat face to face with a man wearing a white robe beneath his winter coat. The man looked directly into the camera but his "privacy" was to be "respected" by turning his face into that of a blurry apparition. This virtual vision of East London revealed unnatural seams in the traffic signs for "calming junctions" and created Cubist distortions in the images of windows and shop fronts, as if the whole scene had turned supernatural.

The screen shifted again to the corner at Burslem Street, and I glimpsed a man chatting on his mobile phone outside an NHS Centre. I clicked again and the man vanished entirely. This accident of corporate surveillance had captured the drama of the ordinary and transformed it into a ghost story. When I visited Hessel Street in person, the real thing was yet another case study in London's endless supply of places where my transient presence was tolerated even though I obviously didn't fit in. I didn't wish to bother the patrons of the Muslim shawl shops and the crowds of kids returning from school by taking photos, but later I did capture one blurry image of the apartment complexes at night. The change in the look of the street since Vas's time suddenly seemed less important than the continuity of this area's peculiar magic.

At Princelet Street, Google Street View captured a film crew waving and giving a thumbs-up back to the camera—an eternal loop of twenty-first-century digital feed-

back. They were standing outside a couple of large white rental trucks in front of a building whose red decaying facade looked like it had been carefully allowed over the decades to peel in order to achieve a period look. Most of the rest of the street had been transformed either into heritage sites with plaques or what looked like high-end flats. This corner however had been left dilapidated, it would seem on purpose, for use as a set.

When I visited Princelet Street this effect had been deliberately spoiled by a mocking street artist who had put stencils of Alfred Hitchcock on the building walls. Hitchcock's face was in pranking mode, and he held his index finger to his lips to suggest that the viewer ought not let on that we understood his joke. I might have been missing some vital context for the image, but it seemed to me that this authorless intervention had several layers of wicked humor embedded in it. First, it wrecked the effect of the "shabby" building required by film and television to exist on this spot in the East End. Second, it teased the media insistence on using the lens of crime for this area of the city. Hitchcock's early silent masterpiece *The Lodger* took up the local case of Jack the Ripper. Now Hitchcock's face floated only a block away from Hanbury Street, where one of the Ripper's real victims was said to haunt the street. Third, Hitchcock's silencing gesture seemed to indicate a witty self-awareness about how the sensationalism and shock of fictional thrillers had become little more than silly games. If you wanted to film here, the graffiti seemed to suggest, you might try doing better than simply adding more layers of mythology to a tourist attraction based on episodes of someone else's trauma. Hitchcock was right to shush his audience in this temporary installation and to try to delay, if only by a few hours, the next set of establishing shots for yet another period melodrama. It felt natural to want to visit such a resonant spot, but I took comfort in being confronted with this sly reminder that I was just another voyeur.

LISTEN
TO BRITAIN

WHEN MY WIFE was growing up, the wall of her family's back garden near Highbury & Islington Station had tilted from the nearby blast of a V-2 rocket during the final days of World War II. Emily's father, Christopher, told stories about life in Hornchurch during the Blitz. Seeing an armada of Nazi bombers building across the sky one night in 1940, and then finding one that had crashed (or had been shot down), demolishing two houses in the neighborhood. Spending time in the Anderson shelter in the back garden, and diving for cover on a walk with his father and the dog as a German fighter plane swooped in a daylight raid to strafe the RAF base nearby. Returning to London from the North in 1944 only to witness a V-1 float down and land on a friend's house.

Blitz specials on British television—a cottage industry—sometimes focused on lesser-known aspects of the bombing campaign. One program told the chilling story of how the government installed retractable floodgates in some of the Underground stations where civilians sheltered along the river during Nazi raids. The floodgates had been designed so that if a bomb hit the wall separating the train

station from the water, everyone inside wouldn't drown. According to the program ordinary people weren't told about the existence of the floodgates, or the danger. Londoners continued sleeping in the riverside stations near the Thames, their heads resting so many feet or inches away from the tiled walls separating them from the water. They slept in cramped rows on the platforms and the tracks, with children's hammocks suspended between the rails and ad hoc coatracks set into the walls above. People also slept in the trains themselves, their blankets falling into the gap between the train and the platform. If the photographs could be believed, they slept in bunches at the bases of the stairs and on the stairs themselves.

London Can Take It! was the staunch title of Humphrey Jennings's 1940 short film about the Blitz, narrated by American correspondent Quentin Reynolds.

"These are not Hollywood sound effects," Reynolds noted as explosions from antiaircraft guns lit up the night sky. "This is the music they play every night in London—the symphony of war."

Jennings's footage depicted life in the bomb shelters: crowds lining up for a safe place to spend the night; a child sleeping between her parents; men playing darts. They surfaced the next morning—"London shakes the debris from her hair"—and returned to streets of rubble, exploded churches, craters in the sidewalks, shattered-glass shop fronts.

"I am a neutral reporter," Reynolds drawled. "I can assure you that there is no panic, no fear, no despair in Londontown."

A day or two before I left London, my friend Ben and I walked in the winter rain down to Owen's Field, just south of the Angel where Owen Street met Goswell Road. We had located a plaque on the grounds of the City and Islington College commemorating a horrific episode from the Blitz. On October 15, 1940, a pipeline carrying drinking water into the city was hit and flooded the basement shelter of the Dame Alice Owen School, killing many of those inside. The guard at the barrier of the college grounds firmly resisted our request to get inside the security perimeter for a closer look at the plaque.

I was not a neutral reporter and I could not assure anybody that there was no fear in Londontown, but after being turned away we had to agree that the guard's actions were fair enough. I recalled Ben's phlegmatic reaction to my panicky transatlantic phone call after the London transport bombings of 7/7. He had said something along the lines of, "Yeah, I'm fine. I walk to work." I remembered that he'd been visiting me and Emily in New York in August 2001 and that we'd gone up to the top of the World Trade Center together. They had a system where they took your photograph in the lobby in front of a painted backdrop of the Twin Towers and then tried to sell you the picture when you were high on the view at the top. We didn't own a television on September 11 but we had watched the rubble smoldering from our rooftop across the river miles away, safe in Queens. I finally saw footage of the towers falling a day or two later on a TV display near the barricades at Union Square, simultaneously broadcast on a dozen screens. The images

had been set on a loop as if the attacks would never stop happening.

Our false impression of our own relative proximity to all of these bombings was a curious contemporary illusion. We were living in the target cities but so were millions of others. And the persistently presented analogies between our era and 1940—the KEEP CALM AND CARRY ON sloganeering that appeared on tea mugs and T-shirts across the globe—felt weirdly off-key. ("Carry On" and "Chin Up" appeared on a publicly displayed poster glimpsed in *London Can Take It!*) What was calm about the hysteria over migrants and refugees that gripped Middle England and Middle America? Panic and chaos seemed to be the keynote of media coverage, public sentiment, and government policy, from immigration and economics to security policy and the general outlook about . . . everything. I had the uncomfortable feeling that our two nations were beginning to act eerily like the poor caged dogs that had been experimented on during the development of the psychological theory of "learned helplessness." When the animals were given electric shocks at random or without any easily discernable pattern, they turned on one another, biting anything nearby. Like the person or persons unknown I'd read about in a tiny news item who had thrown a Molotov cocktail into the precincts of the Finsbury Park Mosque.

On another day out, in a location undisclosed but just south of the river, I had encountered a folk art mosaic of Edward Snowden. Immense care had been taken with the painted tiles that formed his instantly recognizable face,

mild looking in his spectacles, ready to divulge shocking state secrets. This homage surprised me with its attention to detail and deliberative care. At first I thought the artist was attempting to establish a shrine. Later on it occurred to me that there might be more to the project than met the eye. This anonymous artwork, not a million miles away from the building site of the new American embassy in Nine Elms, protested the emergence of global digital surveillance. But nobody had stopped the mosaic from going up on a public wall. How long had that process taken? Was there a CCTV dead zone in the area? Maybe the footage had been captured after all but never processed, recorded but never watched. Or maybe it had been viewed but dismissed as trivial, threat-potential-zero, funny stuff. I pictured a basement room where a police functionary sipped tea from a KEEP CALM mug,

bemusedly watching this Banksy-in-training positioning her portrait of Snowden for the camera, tile by tile. The video files of this action artist, if they existed, must have been stored somewhere, lying in wait for future curators to recover this image of life during wartime.

VISIBLE

ARTIFACTS

SHAKESPEARE LESSONS

THE JAPANESE TERM for them was *shōhin*, or "little items." The novelist Natsume Sōseki, author of the modern masterpieces *Kokoro* and *I Am a Cat*, wrote a series of these autobiographical vignettes for the paper *Asahi* when he was living in London from 1900 to 1902. "This is a very strange city," he noted in "Impressions." He spent much of his time in boarding houses all over the city: North London, Camberwell, Clapham. He felt too broke to socialize, although his landlady in Clapham suggested that he try bicycling in Lavender Hill. His London exudes exquisite loneliness—he called it "solitude" but his dislocation provoked sorrow. He wrote a splendid sketch about walking around in dense fog, each four square meters of the city reduced to a private universe. Sōseki collected books in English and gathered knowledge about British culture; later he would become a professor of English literature back at home in Tokyo.

His English library can be visited, for now, at the Sōseki Museum in Clapham, located in The Chase across the street from one of his least unhappy London lodgings, a place where he met several other Japanese boarders. Odd

how writers lure their readers to visit the places where they lived and worked. More strange still for other writers to fall into the same trap, since they ought to know better about the noneventful life required for work, long days staring in silence, unproductive by every appearance. Sōseki himself had been lured by writers to England. Reading Shakespeare tricked him into spending seven shillings per lesson to study the Bard in London with William James Craig, who became editor of the Arden Shakespeare around the same time that Sōseki studied with him. Sōseki described Craig as a dotty don who required his housekeeper to help him locate his own copy of Wordsworth. Craig spent their lessons rambling, borrowing money from his pupil, and showing Sōseki the piles of notebooks that composed Craig's great, mad, unfinishable project. It was a comprehensive Shakespeare glossary or concordance that spanned every line of every play. When reading Craig's introduction and notes for the Arden *Hamlet*, long after their meetings ended, Sōseki discovered to his utter astonishment that the man was deeply versed, truly learned: "There is probably no other book whose annotations reach such profundity and hit the mark, a fact of which I was not aware at the time."

I should not have been so amazed by the desire of readers to meet the writers they admire, or to visit the houses where they once lived. The London fashion for blue plaques rewards the city's literati for dragging in more tourists. It might have worked out, purely by chance, that the great novelist got along with the scholar he had admired, but Sōseki's encounter with Craig seemed the

more likely alternative. What you wanted to know was already in the books, and that in fact was the reason why the person wrote them. Did anyone think that writers would write if there were any other way for them to live? Did anyone really want to know a writer's third- or fourth-best self, the botched first draft of their everyday conversation?

Surely the same went for the current fad of retracing a writer's steps on their travels—why did visitors flock to Dublin rather than Zurich or Trieste for Joyce's Bloomsday? Even better to stay at home under the duvet with *Ulysses*. I once went to the birthplace of Karl Marx in Trier with my uncle, where I was immediately drawn to the facsimiles of the Crystal Palace visited by the political philosopher in London, and the game of "Confessions" that Marx's family used to play to while away the hours at 9 Grafton Terrace in Kentish Town. Completing the loop at Marx's burial place in Highgate added a little value to these trips. But a question remained: Why didn't we get a life of our own?

Sōseki's best-known London jaunt involved visiting the Carlyle House in Chelsea. You could feel the threads of Sōseki's notes on London drawing together as he basked in the literary shadows of the Cheyne Walk—the Carlyles, George Eliot, Tennyson, and Dickens. When his loneliness turned desperate, Sōseki found friends in the past. Sōseki described Carlyle writing from Chelsea about "looking in the direction of London," back toward Westminster Abbey and St. Paul's. In the twentieth century, Sōseki noted, Carlyle's specific phrasing about the

topography sounded absurd, since the neighborhood had been absorbed by that time into the urban tissue, making it impossible to look "in the direction of London" from Chelsea. "It is little different," Sōseki wrote, "from the absurd reasoning of wanting to look in one's own direction with one's own eyes." Not a bad description of the creative process at all, most books being botched selfies.

Some tourists travel to Carlyle's House to compare notes with Sōseki himself, after a manner of infinite regression, annotation upon annotation. I had hoped to do that myself, but my bus was trapped in traffic and the Carlyle House had closed its doors by the time I arrived. On the bus I had passed a row of flats where a man stood naked on an upper story, looking out frankly at the passengers on the upper deck. (I suppose it was our decision whether or not to look back.) At another intersection I watched a man and his son writing hearts in the fogged-up windows of the bus opposite mine, before our journeys diverged. From the end of the bus line in Battersea Park I could have walked south to Clapham to see the Sōseki plaque. But I didn't, that day.

The great novelist had been disappointed that London had not remained the way it had been described in the books he loved. The city's indifference, its ugliness, its prices and pollution, and its auditory overload—"the church bells, the whistles of trains, and all the noises of this vile world"—disillusioned Sōseki. I would have to disagree with him, halfway. London is a horrible place to visit, but I would want to live there.

THE BEGINNING
OF THE END
OF THE AFFAIR

THEN I VISITED CLAPHAM during the summer, with horribly sunny weather and sickly sweet unnatural warmth that lasted for days on end. All of South London would remain forever mysterious to me, but Graham Greene's *The End of the Affair* (1951) was a favorite novel. The movies had botched it twice, in the 1950s and again in the 1990s. The novel's seemingly unfilmable nature intrigued me, especially since other Greene stories lent themselves so well to adaptation. I wanted to see the environs in which most of the novel was set: a tightly controlled arena of lust and tears arranged around a pub, a church, an adulterous bedroom, and a writer's apartment on Clapham Common. I hoped for rain—Greene had immortalized the Common as the fitting location for soaked souls trapped in doomed and cloudy affairs. The remnants of an Atlantic hurricane finally obliged me by driving wet leaves down the Long Drive and filling the sky with eerie bulbous blue-gray thunderheads.

Greene himself had lived on the north side of the Common in a ritzy-looking row of St. Anne's-style homes, their facades now heavy with blue plaques, where Grieg

and Sōseki had stayed in London. But Greene's narrator and antihero, Maurice Bendrix, lives at the "wrong—the south—side of the Common." Setting off from a pub across the green in filthy weather, Bendrix encounters his lover Sarah's husband, Henry Miles. The two men retreat from the rain into the pub, which Greene calls the Pontefract Arms, a place with "tough and ugly" Victorian stained glass so sturdy and thick that it had stood up to Nazi bombing. Henry doesn't know about Bendrix's affair with his wife, so after a drink at the pub and a whisky at Henry's house the husband proceeds to cry on his betrayer's shoulder about Sarah's double life. Henry knows she's with someone else that night and he floats the idea of Bendrix following up with a private detective he plans to hire to keep tabs on Sarah. The situation for Bendrix becomes excruciating because Sarah isn't at home when he and Henry arrive at the north side of the Common. The implication: she's seeing a third man. So Bendrix agrees to "help" Henry by entrapping her.

Greene's novel recreated in fiction a remarkable turn of events in the author's own life. In 1940 Nazi bombers destroyed Greene's flat. But the place was empty that night. Greene's wife and children had been evacuated from London. Greene himself wasn't at home. He had been staying with a lover, the story goes, and so he had been spared. What a situation for a lapsed Catholic to build a novel around! His life had been saved by his sins.

Bendrix pursues Sarah until he finds out that she's not having a second affair after all. She slips away from home to attend church at St. Mary's, a small Catholic

church near the Underground station, just down from
the south side of the Common. She deserts both her hus-
band and her lover to pray, after promising God during
a bombing that if Bendrix's life is spared she will never
see him again.

I took a copy of the novel to the Windmill Pub, the
real-life analogue of Greene's Pontefract Arms, search-
ing for the Victorian stained glass. Green and yellow, just
as described in the book. The friendly bar staff obliged
me—"something warming?"—when I appeared out of
the rain to drink alone in the middle of the afternoon. I
didn't think to order rum, which would have been Ben-
drix's choice.

IN THE WINDMILL I thought about my own affair with
Emily. It had started out as an illicit weekend nearly
twenty years before. For a birthday present Emily took
me to see Fiona Shaw in a ferocious one-woman show
of *The Waste Land* in Wilton's Music Hall, which had re-
opened after years of disuse for this show. On the train
together afterward, London didn't feel anything at all like
T. S. Eliot's Unreal City, with its depressive crowds of un-
dead. And the next night, or soon afterward, we walked
home to Emily's flat in the predawn after a midnight
screening of *Jackie Brown*. As we passed along the mar-
gins of Highbury Fields, I told her that I wanted to live
there and she was polite, explaining that actually she had
grown up within a few minutes' walk, in Crane Grove.
Our affair led by a long, meandering path to marriage.
At the time, though, I got slapped in the face for it, and

deservedly so, by my girlfriend at the time (let's call her Catherine). The only feature of my love affair with Emily that surprised me was the sheer length of time it took for us to figure things out. We broke it off after that weekend but remained friends somehow.

We'd first met in college but didn't date. I admired her from afar. Emily had flaming red hair (done with henna, German style) and she wrote poems about whales that made everyone cry. She inscribed a book of poems by Anne Sexton to me after I received a scholarship to study in England, describing London as "a sad and angry garden." We met again when I was in Cambridge and she had moved back to her parents' flat near Finsbury Park after college. After our weekend together touring the city and kissing, we decided that dating each other would be a bad idea.

Eventually I somehow ended up in Boston, where Catherine had a place in graduate school and I had nothing much. Things did not go well and she left me, very sensibly, to get her own place about ten weeks after we relocated. Dumped, I knew three people in the city, and I had come to Boston without a job, with the vague hope of writing a novel. It had been a silly plan. I was too depressed even to buy a bed after Catherine moved it and our goldfish-patterned shower curtain to furnish her new place. I slept on a frameless futon cushion I'd found in the hallway that someone in our building was throwing away. I was absolutely not fit for human contact, lost in a fog of unemployable drifting and quasi-suicidal daytime sulks. I didn't realize what had happened to me until the

spell lifted months later, but in the time I lived in Boston I was in a deep, dark well of depression, the well where a monster lived, like the one that was depicted in the movie *The Ring*. Boston did this to people, I found out later on from several friends whose lives and relationships had been shattered by that cursed city.

Catherine remained generous and dignified throughout our breakup, lifting herself on tiptoes to hug me during our last moment together. She had always understood things about kindness that I didn't, and she had paused to savor this one last touch, like a volunteer in a zoo saying goodbye to a tormented bear that needed to be put down due to wounds self-inflicted through bad behavior. She gave me every opportunity to remain friends afterward, but I blew it because I was still too angry and I had confused my depression with everything that existed in the world. After his death, I discovered that my grandfather had kept up a cordial secret exchange of holiday cards with Catherine years after we had split up and no longer spoke to each other. I was touched by this simple courtesy between two people I had dearly loved who, unlike me, knew how to act.

With nothing to keep me in Boston I drifted down to New York, where a college friend had offered me a room for less than three hundred dollars a month in a shared apartment in Bushwick. It wasn't a room but rather half of a room, the windowless half, divided by a sheet. Our landlady lived downstairs and there was no locked door between our floor and hers. At 7 A.M. she shouted at her children until they stumbled out the door for school. Our

backyard overlooked a rubbled lot, which seemed to sum things up.

I rode the subways during the day, openly weeping, scouting for places to jump, and walked Brooklyn and Manhattan until pure exhaustion saved me from my ridiculous self-pity. I wrote bad novel drafts and awful letters—my essays were better but I didn't take them seriously enough to make backup copies, a move I regretted when my laptop was stolen and I lost a year of work.

By pure coincidence, at this point Emily lived in Queens, having moved back to the States from London. We hadn't seen each other in a few years but she knew I was in deep trouble. On my birthday she gave me a card filled with vocabulary words she suggested I could use in a book—"some words, in case you ever need a few"—and offered me the key to her studio apartment on Steinway Street.

"I'm at work all day," she pointed out. "You could write in my place."

That moment marked the point at which life began again for me, when I started trying to write seriously and when I began my long, slow climb back from the distant galaxy of depression. We watched our city burn on September 11, 2001, and held hands at the barricades on Fourteenth Street. We cried at Ground Zero watching the workmen take apart the remnants of the towers with blowtorches, and the National Guardsman stationed there handed us a box of tissues. We left town a couple of years before the next catastrophe hit, the big financial crash.

Since then we had lived together in San Francisco, Cleveland, and Washington, D.C., but we tried to visit London whenever we had the time. That was our story—not nearly as good as Graham Greene's. But like Greene's it insisted on the question of serendipity. Why is it that we were saved and others were not? Saved from what, and by whom? And for what purpose? And for how long?

I SIPPED COFFEE in the Windmill and thought about my grandfather's stories about life during the war for American soldiers in England. I remembered the disastrous but strangely fascinating movie adaptation of *The End of the Affair* directed by the great Edward Dmytryk and released in 1955, starring the unbearably dreamy Deborah Kerr as the adulteress Sarah Miles, an understated Peter Cushing as her husband Henry, and a battered-looking Van Johnson as Bendrix. The decision to make Bendrix into an American writer felt truly deranged. But this fatal adaptation error followed the contemporary trend for postwar English pictures featuring Hollywood stars slightly past their shelf life. The irony of transforming one of Greene's most autobiographical characters into a stormy romantic Yank—the picture should have been called *The Unquiet American*—shocked me the first time I saw the film. The movie had another point of interest, which was the involvement of producer David Lewis, the gay partner of director James Whale (who had made *Frankenstein* for Universal). When Neil Jordan remade *The End of the Affair* in 1999 with Julianne Moore and Ralph Fiennes, the

emphasis turned to carnal bodies, pert butts, pale fronts, moaning, typing, garter belts, and so on. But in Jordan's hands the film's ending, with Bendrix and Henry (Stephen Rea) living together as bachelors in the Miles house after Sarah's death, seems to contain a subtle homage to all forms of forbidden love.

My grandfather's artillery unit kept a diary of their movements during the war, and someone had peppered it with commentary about the food and the people—well, actually, the women—of England, France, Belgium, and Germany. Red Cross girls in Greenock, Scotland, glimpsed upon landing; cheerful waving crowds in bombed-out London; dances, beer, and vague hints about prostitution in Bude, where the gunners fired howitzers into the sea. An anecdote from the unit history:

> One incident happened in Bude that we will never forget. That was the salvaging of a cargo ship that went down off the coast. It was carrying all kinds of American supplies and some of almost everything washed ashore. There was everything from peanuts to shoe polish to radio parts. We worked several days collecting the things that washed in.

My grandfather stayed in Bude during the month of August 1944. It was the same summer that that the V-1 rockets ("strange new weapons" that droned "like bees," according to Greene) hit London. In *The End of the Affair* Greene used the V-1s to restage his own earlier real-life escape from the Blitz through adultery. When the novel was published in England it was dedicated to

"C.," but when it appeared in the States this changed to "Catherine." (Greene brilliantly conflated time and storylines—his affair with Catherine Walston hadn't begun until 1946.)

I'd like to think that my grandfather's lifelong love for everything "English" was the result of an affair in Bude or maybe even in London on R&R. But his anecdotes about wartime, combined with the available social history, suggested any sustained relationship would have been unlikely. Prostitution, on the other hand, sounded omnipresent, almost inevitable. He once referred to certain "ladies of the town" in Lorraine. When I asked him what they'd done in Cannes during his leave after the war ended, he replied, bluntly, "Anything we wanted." That, combined with references to "the legend of sandbag Annie" in the unit history, told the tale more honestly, I guessed. "Though they still won't admit it," the military historian wrote, "some of the men knew her [Annie] quite intimately before we left Bude."

As for London, prostitution was rife. According to Philip Ziegler's book *London at War*, as early as 1939 "an army of harlots moved in to take advantage of the blackout and the prevailing mood," with representatives of the Public Morality Council solicited by over thirty different women while walking at night in Soho. There remained the delirious possibility of English girlfriends. But that sounded more like the movies.

IT MUST HAVE BEEN the setting. I sat in the pub in Clapham and imagined alternative histories for all of us.

Time travel blended with speculation about the interstitial episodes of war. In one story I was in London looking to scatter my grandfather's ashes. Emily and I had never gotten married. After our affair, instead of gradually finding our way back to one another in America, we had failed to keep in touch. Emily had stayed in London and she still lived there. I was here, in the Windmill, waiting to meet her for the first time in many years.

My grandfather had requested that his final resting place be as near to a certain address in South London as possible. The address, he had informed me before his death in suburban Chicago, belonged to a lady he had visited on R&R in London in August 1944 during the V-1 bombings. He wasn't so foolish as to think that the lady would want to keep his ashes. He was confident that I would find the right place to scatter them nearby. He also wanted me to find the address and see if the lady or one of her relatives was still living there. He gave me a large amount of money to give to her, or them, saying that if I couldn't find them I could keep the money for myself.

As I waited for Emily to arrive, I rested the ashes on the floor of the pub in their cheap urn inside my backpack. Nobody had given me any trouble getting the ashes through the border because I had forged a letter from the Department of Defense stating that my grandfather was to be buried in the American fliers' cemetery in Huntingdon, near Cambridge, in accordance with his final wishes to join his comrades in arms.

When I had first arrived in London I visited the address my grandfather had given me in order to try to lo-

cate that lady. I rang the bell and an old woman with a well-worn and somewhat grimly attractive, thin-lipped face answered the door. For some reason I had the ashes in my backpack—it felt very strange to lug them around the city.

"My grandfather was _____ _____," I said.

"So?" she said, looking deeply embarrassed for me.

"He used to visit someone here, during the war."

"Oh," she said.

"He died recently," I said. "He left you some money."

"I suppose you'd better come in," she said, sighing and looking past me into the rain.

Ratty carpeted stairs, her key rattling in the Yale lock, smell of cats and dusty floral curtains in the flat. Cramped quarters. Exhaust-tainted windows from the high-street traffic. Black mold on the rotten wood around the window locks. Waiting in the front room overlooking the street while she boiled the tea. Stained tea cozy, old biscuits.

"What did you say his name was?" she said.

I repeated it.

"Have you got a photograph?"

I showed it to her and her eyes fell.

"He was your father?"

"Grandfather," I said.

"Where did he come from?"

"Philadelphia."

"Tell me a little bit about him," she said.

"His father died when he was two," I said. "His mother couldn't take care of him, so he lived with his aunt and

her husband. The husband owned a barber shop. They moved from house to house to beat the rent. My grandfather became a soda jerk and a shoeshine boy. The war saved him from poverty."

The woman looked out the window.

"No," she said. "Sorry. I moved into this flat just *after* the war. Whole city was vacant, you could get anything for a song."

"Who sold you this place?" I asked, thinking maybe there might be a record of where to locate the previous owner. "A woman?"

"Estate agent."

"I've wasted your time," I said.

"No," she said. "I did have an American in my life, once. Never heard from him again. Do you know anything about DVD players? I'm getting video but no sound. There are all these cords with different colors."

That was that. A few days later I carried my grandfather's ashes into the Windmill and waited to see Emily. The choice of location might have been a little bit melodramatic, but it was relatively easy to get to the airport from here and besides, I had always wanted to visit the location where Greene had set his novel about infidelity and bewilderment. The Common might provide a place to scatter the ashes. I hadn't found any other place that felt suitable.

I sat in the pub waiting for over an hour, but Emily never arrived. She had changed her mind about seeing me again. She had been able to put me away, or else she preferred not to dwell in the past. Love proved less du-

rable than in the movies. People wanted to forget. Impolite to try to make others remember. Not everyone cared about the mania for "reconnecting," restarting a friendship on the site of trauma. Maybe Englishwomen preferred to cauterize the wound.

I was alone. I made my way across the Common, not to the north side but along the south side to St. Mary's Church. The place happened to be under construction, a rehab project with scaffolding disguising the spire. I wandered into the church precincts and nodded at the workmen drying out after the rain squalls. I felt obliged, but also frightened for some reason, to enter the church. I don't know whom or what I expected to find inside. A disappointed priest who was sick and tired of Graham Greene tourists scouring his chapel and its plaster saints for traces of Sarah Miles? Catherine and Emily, holding hands in a back pew, trading stories about my worst habits? The woman I had imagined my grandfather visiting during the war, sending up a quick prayer for or curse against the dead soldier thousands of miles away and decades gone from the cataclysm that had brought them together for a day or an hour?

Of course I found nothing in the church and nobody there in the afternoon between services. In the darkness inside I moved along the pews, looking beyond the partition between the side chapel and the main altar. I did not belong there. Surely it would have been a sin to ask for a favor while bringing no faith, a phony pilgrimage for bogus relics invented in a novel fifty years old. I thought about Sarah Miles spending her final days

in this church, slowing dying of the cold. About Henry Miles and Maurice Bendrix and Graham Greene, and Catherine.

I kneeled in front of the Virgin, but not to pray. I removed my backpack and opened the compartment where I had been carrying my grandfather's ashes. This would be the place for him to rest. But of course the ashes weren't there; that had been a fiction. It occurred to me again that I didn't belong in this place. I made a prayer anyway, I didn't know why. The bombed places of the world.

Then I walked back across the Common and finally rewound my steps toward the pub. Ravens in the paddling pool, "Alpha" courses advertised at the toy church in the park, those old eternal dead leaves blowing in the doors of the pub or skittering like thrown dice or bones across the road. Dossers slept at the old fountain on the other side of the Common. Strangers walked the paths across the green, failing to meet and far too anxious to make eye contact. There would always be that possible glimpse however between solitary walkers, or across the tube platform, or between the glassed-in upper decks of buses passing in opposite directions, or from trains pulling away from one another. All our tangent lives.

ONLY DISCONNECT

Belated review of *The Romance of a Bookshop* by Gilbert H. Fabes (1929)

ANY BOOK LOVER who has visited London knows that Foyles Is for Books. The famous bookshop's palatial renovated building is a shrine to print, enduring after the closure of the Blackwell's and the collapse of the Borders on Charing Cross Road. It's a historical commonplace to refer to London as any point within fifteen miles of the Charing Cross—but the world's book lovers would amend that geographical description slightly to the north, to the doors of Foyles. Suppose you've taken a night bus from Morden to Trafalgar Square and you need to change to the N19 for Finsbury Park Station. Just walk north a little bit and catch the bus outside of Foyles. It's closed at this hour, but the books you've written and the books you want to read are warm inside. The books in the display windows are often arranged according to personal tastes—one of London's most cheering sights.

Gilbert H. Fabes wrote and Foyles privately printed a slim hardback entitled *The Romance of a Bookshop, 1904–*

1929 in order to commemorate the twenty-fifth anniversary of the business established by Gilbert and William Foyle. A photograph depicts the brothers on a tandem bicycle. It calls the writing and selling of books "the most ideal combination to combat the unhappiness of the world." The brothers started off selling stock stored in their kitchen, then moved to a warehouse in North London, a shop in Peckham, and then to Cecil Court and on to the locations near the top of Charing Cross Road. The advertising for Foyles was always charming. One early circular read: "DON'T STAND OUTSIDE IN THE COLD OR RAIN! You are cordially invited to step inside and look around. You will not be asked to buy, but a dull day will be brightened." Fabes's book describes highlights from the mailbag: "Could you introduce me to one [book] which would serve to bring out the dormant powers which, through ignorance, lie sleeping in the majority of common folk?" Oh, Foyles. Before I read Fabes's book I didn't know that in the past Foyles sold used books by weight, twopence per pound. Sometimes their clients just wanted books— any books—and let the bookshop choose the titles. A Freemason was put in charge of Topography, Travel, and Guide Books as well as the Craft, while a master mariner handled Military and Naval topics "below decks." Another gem from the circular: "You will notice how small are our charges for the cream of knowledge."

Stories operate in what David Foster Wallace once called the "brain-voice" of their own era. I actually like e-books, mainly because I have an eye disease and I benefit from being able to adjust the size of the type.

But the number of hours one can spend looking into a screen—even at unprecedented splendors like photographs of the surface of Pluto—has a limit. Things get to feeling *Matrix*-y. With apologies to E. M. Forster, a new slogan might be "Only Disconnect!" The internet—that vast cathedral we all had been tinkering away on building together—feels ruined. Everyone is flocking back to reality. Coffee, knitting, graffiti, babies, cabaret, bowling, music, books, gardening, sex, lectures, meat. It occurs to me that when I'm in London I'm usually without a smartphone and I am often disconnected from the web, an illusion I can recommend. Maybe that's why I like being here. I have memories of actual things. I wouldn't advocate bringing back the blackout, but it would be interesting to build a city without online access.

Foyles seems to understand my basic impulses. The bookshop answers my yearning for something other than stats, Likes, Stars, Hearts, Steps, and Smileys. The basic joys are haptic: needles touching records; fingers touching pens and pages and lavender; fingers touching fingers; films touching projectors; ink needles puncturing skin. The purpose of our hands is evolving.

A GAME
OF PATIENCE

ANOTHER DAY OF WANDERING, out of my element as always, in East London. This time I was looking for traces of W. G. Sebald. I planned an excursion in homage to Grant Gee's film *Patience*, in which the filmmaker followed Sebald's steps on his walks for *The Rings of Saturn*. That film was set on the Norfolk coast but I hoped to transplant Gee's basic idea back to London. My text was *Austerlitz*. I wanted to investigate an odd mistake I'd noticed in the book. To make an afternoon of it, I exited the 106 bus at Museum Gardens in Bethnal Green where a hostile-sounding comment—"Where are the English?"—had been stenciled on my park bench. A large-scale graffiti project just down the way on the Roman Road involved gigantic letters sprayed over the storefronts spelling out "H-O-R-R-O-R," with a cash point situated after the first *O*.

I headed in the direction of Regent's Canal, Mile End, and Tower Hamlets Cemetery. Along the way I photographed the tower blocks that from a distance and in a certain light looked strangely like Florida beach apartments, only without the ocean. The urban experiment:

could people live here and not riot? If so, humanity would emerge stronger. We'd be ready for anything— outer space, the colonization of Mars. I collected images of the worst-looking buildings and put them through weird filters, trying to push them into toxic color washes and HDR cloud effects that would reveal their true nature as abandoned spaceships. But I was the alien in this topography, a little migratory bird lost on the wrong side of the ocean, a gleaner of postcards and snapshots, a glimpser of the cerebral cortexes of street artists, a collector of scraps of useless information. I helped a narrow boat through the gates of a lock on the canal—quick waves of thanks from the couple bouncing their way down to Limehouse Basin at the cusp of the Thames. I saw the phrase "Anti-What?" written on one of the giant handles of the massive wooden doors of the canal lock.

The reason I walked out to Mile End involved the location of a literary curiosity, a translation error in the English-language edition of Sebald's best-known book. He describes his narrator meandering through a graveyard—it had to be Tower Hamlets Cemetery—and visiting his friend Austerlitz in "his house in Alderney Street," as the translation puts it. The English text describes it this way:

> Alderney Street is quite a long way out in the East End
> of London. It is a remarkably quiet street running paral-
> lel to the main road not far from the Mile End junction,
> where there are always traffic jams, and, on such Sat-

urdays, market traders set up their stalls of clothes and fabrics on the pavements. Thinking back now, I see a low block of flats like a fortress standing on the corner of the street.

A good place to vanish, this Alderney Street. Except that it wasn't a Street at all; it was a Road. There *is* an Alderney Street in London but it's in a completely different area, a posh neighborhood south of Victoria Station where the house numbers appear on white columns and where, when I visited this alternate dimension of Alderney-ness, someone had left a bathtub out on the street to be scavenged. Of course there had to be this doubling effect of Alderney Road and Alderney Street, a mirror world that existed on the other side of the universe—and by the universe I mean London—from the place where Austerlitz lived.

Sebald's Alderney was Alderney Road, near Queen Mary University. In *Austerlitz* the title character, at his flat in Alderney Road, plays a homemade game of pa-

tience with photographs. The pictures include "empty Belgian landscapes, stations and Métro viaducts in Paris, the palm house in the Jardin des Plantes, various moths and other night-flying insects, ornate dovecotes, Gerald Fitzpatrick on the airfield near Quy, and a number of heavy doors and gateways." Austerlitz places these pictures wrong side up in random arrangements and then turns them over one by one, as if to create new fabricated landscape collages. The passage recapitulates one of Sebald's own literary techniques, with its jumble sale affect and its market stall photographs and postcards of places, eyes, and so forth arranged as illustrations throughout his books.

As daylight fails, Austerlitz and the narrator set off on foot through Mile End Park to Tower Hamlets Cemetery. I too visited Alderney Road when the light had begun to dim. Trying to get a picture of the sign with the street name, I snapped the picture too quickly and got something blurry. My photographs of this area never seemed to work—as in so many other spots in London there must have been a magical whirlpool here that interfered with electronic signals at certain times of the day. A sepia effect transmuted my incompetent images into a fictional past. (Sebald, according to Gee's film, used to photocopy the photocopies of his photocopies until his images looked bad enough to be useful to his imagination.) I walked by Carlton Square and Gardens, one of the most calming and dignified-looking places in London, locked away in the maze of streets only a moment's breath away from the clattering chaos of Mile End Road.

Once inside the cemetery Austerlitz and his friend re-
mark on the "statues of angels, many of them wingless or
mutilated, turned to stone, so it seemed to me, at the very
moment they were about to take off from the earth." Here
were two walkers with whom I was so eager to link arms,
like the armada of writers that had retraced Sebald's steps
along the coast in Gee's documentary. Sebald captured
something quintessential about the English conception
of the garden cemetery, where the monuments were
designed to decay and the nonchalant graves collapsed
into the earth, choked in vines, shrubs, and cypresses. If
stone was transitory, then what were we?

And then in the middle of this pile of graves I found
myself alone, at dusk, in the odd periphery of London,
looking at an apiary. The Friends of Tower Hamlets Cem-
etery Park had reserved a clearing for beekeeping. This
apiary formed part of "Plan Bee," a charitable enterprise
to restore havens for honeybees, hoping to help arrest
their global decline. The "Urban Bees" group provided
training. Their web site suggested that gentle bees thrive
on the plants of city parks and railway sidings. This
sweetness—liquor of the plants that grow through the
dead; ghostly honey harvested by transmutation from
souls marked in crumbling stone—arose from the heart
of London. I had stumbled accidentally on my grail. I
didn't need to taste the honey to know that I had reached
my destination, discovered something in exchange for
all my aimless days rambling sideways like windblown
trash through this city. Land Rover commercials recom-
mended that one "Own the View." I preferred not to.

I took the wrong way out of the cemetery, walking along Bow Common Lane and Ackroyd Drive, where the boarded-up estates and blocks of broken windows replaced the magpies of the quiet graveyard. Trash heaps swelled in the little urban park of the Ackroyd Drive Green Link. I spotted two dudes on the corner eyeing me back as I passed across the street. I wondered if I had blundered one road too far, finally bumbled into the wrong place, the spot in London where I'd disappear. But I was being melodramatic. These guys were just doing business away from the crowds and the CCTV. Maybe they thought I was a local beekeeper. Or maybe they were police officers in plain clothes. In any event nobody stopped me. I slipped on my ring of invisibility and walked away into the world of shadows.

AROUND CLISSOLD PARK

ONE STARTING POINT for bomb-site walks in North London: 98 Green Lanes, where according to a monument in Abney Park Cemetery, Nazi planes killed dozens of civilians in a raid whose real target was unknown to me, perhaps the rail depots in Hornsey. I found the address—or more accurately failed to find it—in a neighborhood at the edge of Hackney along a row of storefronts that had seen better days. No blue plaque commemorated the people killed there by the Luftwaffe. In fact I failed to locate a 98 Green Lanes at all. The address seemed to have vanished, although I saw entrances labeled 96 and 102. I must have missed something, or else 98 Green Lanes had become yet another one of London's erased secret doors.

I'd been visiting the area around Clissold Park for nearly twenty years. A bite-sized walk from Finsbury Park Station involving the enticements of used book shops, coffee at the Clissold House café, rose gardens, miniature deer, and a strange little aviary. The half-concrete church adjoining Clissold Park, said to be an ancient site of worship stretching back to 1100 A.D., wore

its own marks of the Blitz proudly, its graves arrayed in tousled splendor amid the moldy little paths leading between the park and upscale Church Street.

The Abney Park Chapel, a burnt-out ruin at the center of the garden cemetery, had been left open to the elements for decades. I first read about this "vandalized chapel in the woods" in Iain Sinclair's 1997 book *Lights Out for the Territory: 9 Excursions in the Secret History of London*. My battered paperback copy of this London *Ulysses*, held together by packing tape and bathtub mold, had led me to more priceless spots in the city than any guidebook. One of my favorite sections was the index, ten dense pages of place names and further reading. "Drifting purposefully is the recommended mode," Sinclair wrote, "tramping asphalted earth in alert reverie, allowing the fiction of an underlying pattern to reveal itself."

I saw kindred effects in the London street footage of the Free Cinema films with which I had fallen in love. I read Free Cinema in part as a postwar London rendition of the "city symphony" films of the 1920s, Dziga Vertov in Moscow and Kiev, and Walter Ruttmann in Berlin. Filming and writing the city was an experimental and noncommercial act, art therapy for bad brains.

Impossible project: return to all of the locations described by Sinclair in *Lights Out for the Territory*—emulating Chris Marker in *Sans Soleil* when he traveled through Hitchcock's San Francisco—just to see what the last twenty years had done to London. Abney Park Chapel could form a case study. All that officialdom had managed to do with the site for two decades was to erect a

pointless fence placarded with warnings to trespassers
and notices about planned renovations. "A recent survey
of the chapel has found that work needs to be done to
make it safe for visitors to Abney Park," declared one
sign with a propensity for stating the obvious. Graffiti
above the text asked "WHEN?" On some railings where
the shrubs grew into the windowless open walls of the
church—places where there had been stained glass
long ago—another message pleaded, "SPEND SOME MONEY
ON THIS CHAPEL." In 2015 a casual visitor could continue
using the glassless rose window to create photos that
looked like Black Sabbath album cover art, concen-
trating the sunlight into visible artifacts on the lens of
their camera phone. As I looked into the wrecked shell,
I couldn't help but hear the tuned-down chords of the
diabolus in musica. Surely the place would fit better into
its surroundings as a curated ruin than as a renovation

encrusted with informative placards touting the nearby gravesites of hymn-writer Isaac Watts and the Booths, who founded The Salvation Army.

In 2016 the chapel finally cladded itself in scaffolding, like the rest of London. An indefatigable artist undeterred by the unpaintable exteriors of the construction barriers had sprayed intricate portraits of faces on the *inside* of the building site's temporary walls. One would have to follow the artist in trespassing to view this mural up close. The new aviary, meanwhile, formed a box of densely woven metal. The design protected the birds but also made it difficult to see anything inside.

When I mentioned my recent sorties into the rampant nice-ification of the area, my wife told me that she used to visit the Clissold Park aviary as a child.

"There was a mynah there that could talk," Emily said. "Pretty disturbing. But there really wasn't any other wildlife to speak of nearby."

Other denizens of the aviary included cockatiels, budgies, zebra finches, lovebirds, and the eternal parakeets whose invasive feral cousins roamed certain parts of the capital. When she was eleven years old, Emily had one of her poems selected for a prize anthology published by the Tate Gallery. "A Place" responded to a painting of Letchworth and invoked a fawn. English nature always got miniaturized. But something felt permanently endearing and Londony about the limited ambitions of Clissold Park. A place parents took their children to look at a small array of natural specimens. Fallow deer and goats in a fenced-off enclosure. That's your lot, kiddo.

No wonder it was so difficult to keep Brits on the island once they had glimpsed California redwoods or Spanish beaches.

Just down from the deer park I returned to a spot that had always fascinated me, a restored Victorian drinking fountain at the circular center of a rose garden. This slightly elevated patch of ground marked one entry point into an underground world that involved the history of clean drinking water in London. The original source that fed this fountain was the New River, an artificial network of reservoirs and open waterways stretching south from Hertfordshire. Starting in the 1600s, gravity brought clean water from the New River—free from the impurities of the Thames—gradually downhill, twenty miles through the countryside. Just south from this spot the New River Path followed a quiet green waterway of algae down into Islington. The sixteenth-century historian John Stow claimed that the fields to the north of London were "commodious for the citizens therein to walk . . . and otherwise recreate and refresh their dulled spirits, in the sweet and wholesome ayre." As for the present, it held other charms.

FREE

CINEMA

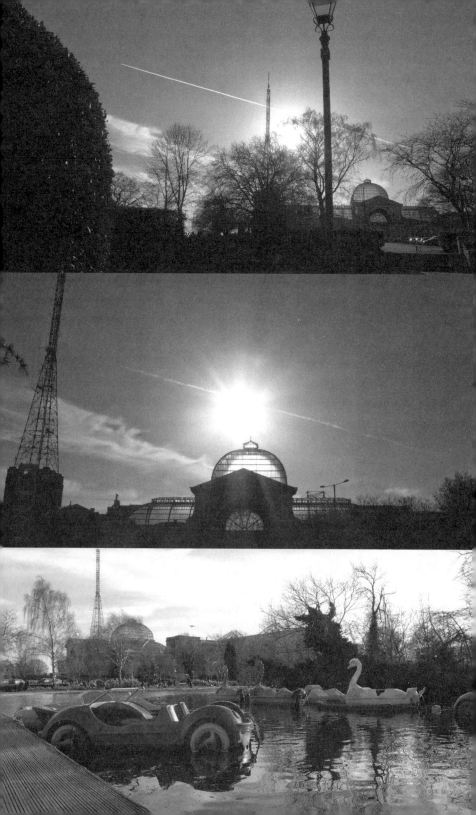

CREATE
YOUR OWN
WORLD

ON A WEEKDAY AFTERNOON of intermittent rain it's better to stay inside and watch television. But if you cannot help yourself and must make contact with the outside world, there's always something to see in the neighborhoods where the boroughs of Islington, Hackney, and Haringey converge. You decide to trudge uphill and see where the water leads you, reversing the course of time. Some of the seventeenth-century New River aqueduct system still contributes to the London drinking supply, you've read, although the flow now gets diverted into modern pipes at Walthamstow. You can walk the New River Path north from Clissold Park to Hertford, some two dozen miles. As ever, you're location scouting for a documentary that doesn't exist. A personal film, only without the film. The Druids, it's claimed, used to arrange "views" in the forests and the hills using vantage points as shrines. But there isn't much demand for Druids these days. You're exploring the city's invisible infrastructure, man-made wonders—one of the artificial sacred springs that feeds London. Think of all those cups of tea.

The voyage out is not for Mars or Jupiter but for Wood

Green and the duck pond behind Alexandra Palace. The
pub at the top of the hill affords splendid views of the
clouds shifting over the toy city. You start at the Old Castle
pumping station (now a recreation center and climbing
wall), past the vast estate being renovated along Brown-
swood Road. The weathered sign for the New River Path
is hidden in the thorns, and a lorry driver with a sense
of fun angles a large puddle at your trousers. That's the
price you pay for looking idle on a Wednesday in North
London. Ducklings and discarded footballs float in the
algae-choked canal near the sailing club at the reser-
voir. Magpies, blackberries, and nettles along the path,
swans and moorhens chilling out, families soaking up
reclaimed green space. The overall effect gives the ca-
sual visitor the unnerving feeling of playing the role of
a computer-generated person "relaxing" in a developer's
online brochure. You have to hand it to humanity—give

us a little stretch of water, even an old canal, and we'll start building along the banks.

The housing development under construction here has been singled out by *The Guardian*'s investigative reporters as a particularly egregious example of London's inequality. The visual effect of seeing the old estate and the new glassed-in flats side by side induces shock and bafflement at such audacious social engineering, which is totally reliant on the decency of the poor. At one edge of the snapshot gleaming boxes rise over the sails of the boating club. At the other edge looms a broken chipboard sign for the older flats. These sets of buildings might be doppelgangers symbolizing two Londons. This estate's dubious claim to fame before the current condo invasion? Supposedly it had been used to emulate the Warsaw ghetto as part of the backdrop shots for *Schindler's List*.

Joggers toil under their neighbors' satellite dishes and broken plaster. The fenced-off wetlands area closes early, but you can walk the public footpath along the fouled canal, visiting the moorhen that sits near a little footbridge like a neighborhood monarch atop her massive nest of twigs and Doritos bags. New River Way, Hackney: images at the construction fences of the building site depict the recreation lake with the iconic Gherkin skyscraper designed by Norman Foster—in reality five miles away from here—in the backdrop. Perhaps the world's longest zip-line could be installed between these two points for the commute home to this "affordable" postcode.

Move on. The spot you're looking for lies on the other side of Finsbury Park and Seven Sisters Road. The Har-

ringay Passage forms a charmed lane wandering uphill through Victorian neighborhoods of bay windows and garden cats. The passage has a less picturesque origin. It is the former pathway of the Hornsey outfall sewer. The passage got preserved in part because nobody wanted to build houses there. At this point the New River Path is blocked off, but the passage creates a good retreat from the rain, where a solitary walker glimpses the third London borough of the day amid the wet footsteps that echo and squelch against the flagstones and close walls, keeping away the worst of the downpours. (Apropos of the passage's original usage, the locals had a saying in the nineteenth century: "Highgate's rain is Tottenham's pain." It rolled downhill from the wealthy hills to the poorer lowlands, causing outbreaks of cholera until Victorian sewage works solved the problem.)

The leader of an ad hoc meeting of outdoor drinkers on the bridge back to the New River Path tells a passing kid not to worry, their dog is friendly, all sorts are welcome here. The old canal widens as it travels from the Thames Water pumping station on the hill near Alexandra Palace. The Gospel Centre in Thornpike Green displays a placard from Corinthians: "We walk by faith, not with eyes." Although eyes are good too, one supposes, for walking around.

During working hours another housing development near the filter beds conveys that strangely abandoned look peculiar to certain canalside apartments in London. The construction materials appear prematurely faded so that the buildings often look much older than they really

are, and nobody seems to live there in any convincing or permanent-looking way. The government might fence it in with barbed wire and add floodlights. Or alternatively developers could create a string of canalside gastropubs. These strange-looking nonneighborhoods are one step away from two very different fates—it's that flimsy look endemic to our era's hasty assemblages. The overall impact on an ignorant intruder feels redolent of a furniture showroom in a suburban shopping mall recently hit by invisible poisons or radioactivity. You half expect to see the residents politely nodding to one another in gas masks.

An attendant very quickly chases you out of the Recycling Centre near the industrial park past the filter beds, explaining that the place is closed.

"How did you get in?" he asks. "The gate's closed."

"I just walked," you say.

"Why are you taking photographs?"

You gesture to some discarded paint cans stacked in neat rows.

"It's interesting looking," you say, helplessly. "I like the shapes."

Hearing an American accent, he cracks the briefest smile and shoos you away past a photogenic array of broken televisions. He's a vigilant public servant taking pity on an obviously insane foreigner who has somehow become detached from his tour group, wandering the city edges, taking pictures of trash.

Wood Green on an ordinary afternoon. You're reminded of the footage of the local meat-cutters and dental

assistants recorded in Karel Reisz and Tony Richardson's Free Cinema documentary *Momma Don't Allow* (1956). Their subjects wait for their working day to be over so they can dance all night to jazz at a local club. Reisz and Richardson shot their film over nine Saturdays, according to their programming notes. They said they wanted to look beyond the class prejudices of traditional British documentary, in which poor people tended to be viewed as helpless victims or charity cases. Here, Reisz and Richardson said,

> we felt free not to disapprove of teddy boys, not to patronise shop-girls, not to make sensational or hysterical a subject which is neither (but is almost always shown so). Suburban London jazz clubs are run for and by enthusiasts . . . who, on several evenings each week, meet and create their own world. It is the freedom, exuberance, and vitality of this world that we set out to capture and to admire.

The action of *Momma Don't Allow* takes place in and around the environs of the Fishmonger's Arms, with the accompaniment of Chris Barber's band. A banjo and clarinet play the blues while a woman in a kerchief cleans the floors of a restaurant, a butcher sharpens his knife, and a girl in a lab coat with closely cropped hair sees a patient out of a tooth-cleaning appointment.

We'll soon see these same figures transfigured at the dance hall attached to the pub, smiling and swinging under a mirrored ball while knots of youths in suits watch from the edges of the room with their mugs of

beer. The restaurant floor-cleaner, now dressed to the nines, leaps into motion and whirls in circles. Wealthier-looking patrons arrive by car, careful to remove their hood ornament before parking in this neighborhood. The dental assistant abandons herself to the music, moving closer and farther away again from her partner. Another man signals that he's afraid to dance but looks happy to watch. The place is massive, and packed. The mirrored ball keeps time for the film. The music slows and the dancers blow smoke rings while couples noodle and kiss, or fight. Loungers nod to the blues then hop back out to dance their eyes out during the up-tempo renditions of the New Orleans sound.

The radical filmmaking experiment here lay in showing what life's really like. Nine Saturdays of filming become one eternal night in which the stars are the shopgirls of Wood Green. The film ends before we can see them return to their jobs—that means they never have to go back to work.

If you had to choose a single place to make your own picture of London, you would select Alexandra Palace, up the steep hill from Wood Green. When it's not being used as a concert venue or a fairground for antique dealers, funfairs, or craft beer tents, snooker tournaments, or darts championships, Ally Pally is usually fairly quiet on weekdays near sunset. The fact that nothing very exciting happens here is a plus for your purposes. The building itself comprises Victorian brick with a partial skylight roof—a "People's Palace" with wrought iron "AP"s and double-headed lions patrolling the lampposts on the paths. A farmers market

on the weekends in the park. A garden center serving the allotments on the Park Road. Bus shelters stationed near the pub and the ice rink. The rose garden. The duck pond.

Nobody notices you here. Difficult to imagine, but for many decades, you've read, Alexandra Palace was considered vulgar—a folly and an eyesore. It would be the ideal spot for spies or lovers to arrange their affairs, a secret place in plain sight, a private nook open to the public, an open spot above the maze of the city. It was here at Ally Pally during World War I that the British interned German civilians on the flimsy basis that they might be a threat to national security. Starting in the 1930s, the BBC broadcast its first high-definition television signals from an antenna attached to the building, one of the highest points in London. The current plan approved by the local council is to transform Alexandra Palace (large sections of which remain empty and disused) into a theater and an exhibition space about the television studios.

You can see almost everything from here—from the Olympic Park to Canary Wharf, the City, the Shard, and all the way around to the BT Tower. London, from east to west, in a single sweeping snapshot, everything central distant and tiny. Turneresque skies loom above the palace with its presiding angel perched atop the roof and the massive old obsolete antenna jutting into the sky above the angel. Couples and families from all over the world congregate here to do nothing and not to worry for a while. All this for the price of a bus journey. Picnics and push-chairs, headscarves and pints of beer. The sense of discombobulation, a jumble of historical associations, all

emanate from this ur-source of television transmissions, the pipe of official information and decades of entertainment beamed into millions of homes over generations of Londoners. At Alexandra Palace nobody can be turned away for lack of cash and the rose garden attracts hand-holders and families alike to its concrete fountain.

At the outside tables near the pub it might be raining while the sun is out, or freezing in the height of summer, windswept or warm. Even as dark clouds gather over London's financial district off in the distance below, there's never a day on which you cannot appreciate the simple good fortune of a day off. Rain streaks down over the Thames and the hills beyond the vast capital, but for the moment the sun glints in your glass of lime cordial and sparkling water, transforming the drink into a one-pound elixir.

It's a balm, this feeling. Time to forget. Put away your notebook and go for a stroll around the little boating lake, amid the languages of the world. The tickets for the swan-shaped boats are for the kids. Local adolescents

grind on the concrete skateboarding park. You can almost breathe the air up here. The budget for your day out adds up to less than a fiver, including the lime cordial and your bus journey down the hill, back into the city you love and which can never be yours. But this memory palace is different. It belongs to anyone who visits.

ACKNOWLEDGMENTS

I relied on my own memories of London from 1996 to 2016 (pre-Blair to pre-Brexit, with the EU referendum results unfolding after this book entered production). In addition to the sources already mentioned in the book, I quoted from a pamphlet of Free Cinema texts distributed with the Facets Video American DVDs. I drew on details from Sean Coughlan's "Wild Parakeets Settle in Suburbs" (BBC.com, July 6, 2004) and Aditya Chakrabortty and Sophie Robinson-Tillett's "The truth about gentrification: regeneration or con trick?" (*The Guardian*, May 18, 2014). Facts about the New River were derived from the Thames Water booklet *The New River Path: A Walk Linking Hertford with Islington*, and the list of birds in the aviary leaned on the Hackney Council pamphlet "Animals in Clissold Park." I found John Stow's description of North London and historical information about the New River in Peter Zwart's *Islington: A History and Guide*. Haringey Council provided an informational pamphlet about the history of Harringay Passage. My deepest thanks go to Kate Wahl, Gigi Mark, Stephanie Adams, Jeff Wyneken, Rob Ehle, and the team at SUP, as well as the Stanford University Creative Writing Program, for their generous support. Michael McGriff provided invaluable editorial comments. Ben Walters accompanied me on so many journeys and gave me innumerable notes. Rob White and Rebecca Barden encouraged me to believe I could write about cinema. Joanna Mitchell, Paul Francis, and Skip Horack traveled with me on days out. I think the street art of the bird is by L7m and the overpass family is by Stik; thanks to all the artists who work to beautify London. Marcia Parlow was the recipient of an early version of "Suggested Itinerary." *Bennington Review* published "25 Love Lane" in a different form. A Strange Object posted "Crystal Memory Palaces" in their web series *Covered with Fur*. In "Watching," I recycled from my *AGNI* essay "Displeasures of Empire, or, An American Werewolf in London." I am grateful to the Keasbey Memorial Foundation for sending me to study in England, and to Trinity College, Cambridge, for a College Research Scholarship. Carolyn Kuebler and Professor Stephen Donadio, at *New England Review*, and Professor Rob Tregenza and Dean Nancy Scott, at VCUarts, offered me a supportive atmosphere in which to work. This book would not exist without Chris and Lois Mitchell, and I have Emily to thank for London.

ABOUT THE AUTHOR

J. M. Tyree is the coauthor (with Michael McGriff) of *Our Secret Life in the Movies*, an NPR Best Book of 2014. He is the author of *BFI Film Classics: Salesman*, and the coauthor (with Ben Walters) of *BFI Film Classics:* The Big Lebowski, from the British Film Institute. His writing on cinema has appeared in *Sight & Sound*, *Lapham's Quarterly*, *The Believer*, and *Film Quarterly*. He has spoken at London's National Film Theatre and at the National Gallery of Art in Washington, D.C. He was a Keasbey Scholar at Trinity College, Cambridge, and a Truman Capote–Wallace Stegner Fellow and Jones Lecturer in Fiction at Stanford University. He currently teaches at VCUarts as a Distinguished Visiting Professor, and he is the Nonfiction Editor of *New England Review*.